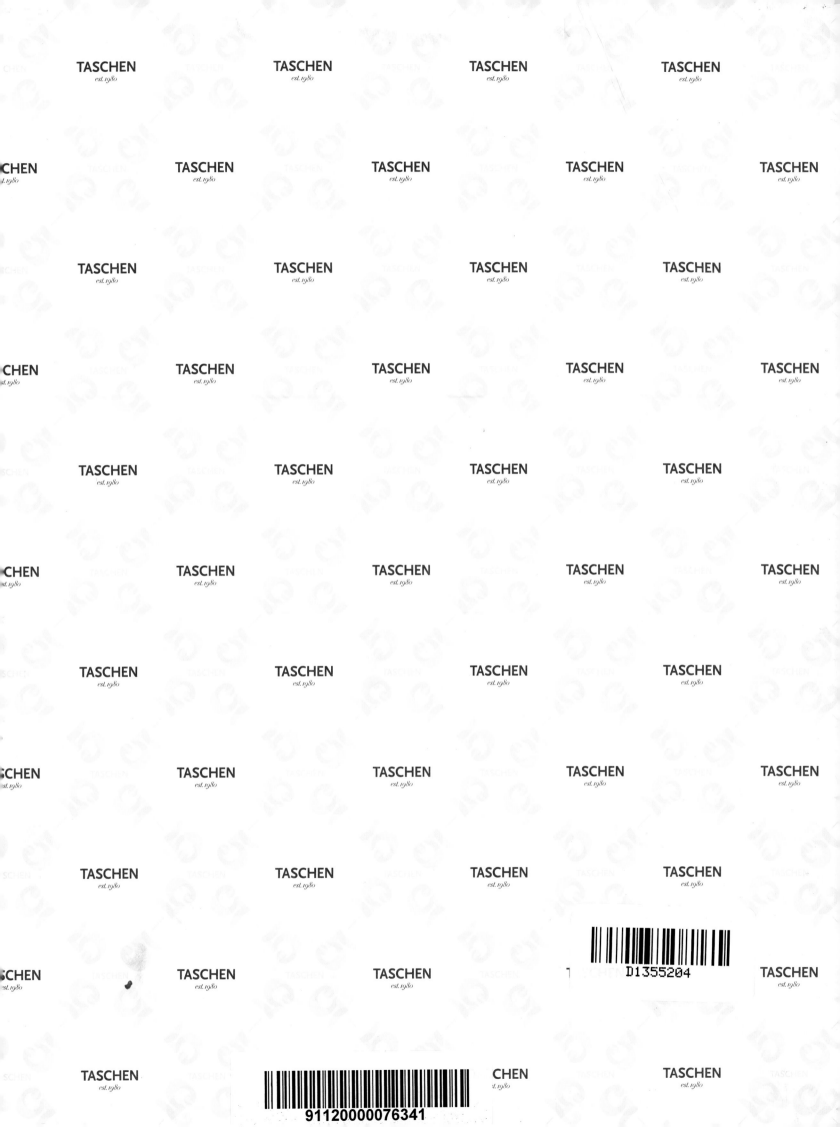

TASCHEN
est.1980

TASCHEN
est.1980

TASCHEN
est.1980

TASCHEN
est.1980

TASCH
est.1980

TASCHEN
est.1980

TASCHEN
est.1980

TASCHEN
est.1980

TASCHEN
est.1980

TASCHEN
est.1980

TASCHEN
est.1980

TASCHEN
est.1980

TASCHEN
est.1980

TASCH
est.1980

TASCHEN
est.1980

TASCHEN
est.1980

TASCHEN
est.1980

TASCHEN
est.1980

TASCHEN
est.1980

TASCHEN
est.1980

TASCHEN
est.1980

TASCHEN
est.1980

TASCH
est.1980

TASCHEN
est.1980

TASCHEN
est.1980

TASCHEN
est.1980

TASCHEN
est.1980

TASCH
est.1980

TASCHEN
est.1980

TASCHEN
est.1980

TASCHEN
est.1980

TASCHEN
est.1980

TASCHEN
est.1980

TASCHEN
est.1980

TASCHEN
est.1980

TASCH
est.1980

TASCHEN
est.1980

TASCHEN
est.1980

TASCHEN
est.1980

TASCHEN
est.1980

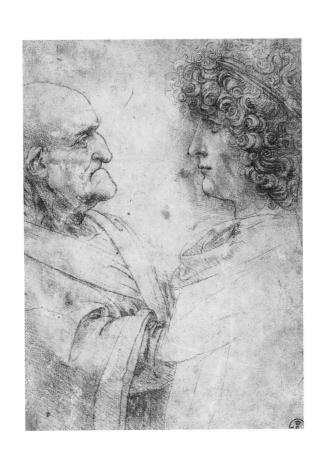

Frank Zöllner

# LEONARDO DA VINCI

## 1452–1519

## Artist and Scientist

**TASCHEN**

HONG KONG KÖLN LONDON LOS ANGELES MADRID PARIS TOKYO

PAGE 1:
*Old Man and Youth*, c. 1495–1500
Red chalk, 208 x 150 mm
Florence, Uffizi

PAGE 2:
Unknown artist
*Portrait of Leonardo*
Red chalk, 333 x 213 mm
Turin, Biblioteca Reale

This red chalk drawing has largely determined our idea of Leonardo's
appearance for it was long taken to be his only authentic self-portrait.
Nowadays it is thought to be a fake, or at best a copy.

| BRENT LIBRARIES | |
| --- | --- |
| **KIN** | |
| 91120000076341 | |
| **Askews & Holts** | 12-Sep-2012 |
| 759.5 | £8.99 |
| | |

To stay informed about upcoming TASCHEN titles, please request our magazine at
www.taschen.com/magazine or write to TASCHEN America, 6671 Sunset Boulevard,
Suite 1508, Los Angeles, CA 90028, USA; contact-us@taschen.com;
Fax: +1-323-463-4442. We will be happy to send you a free copy of our magazine,
which is filled with information about all of our books.

© 2010 TASCHEN GmbH
Hohenzollernring 53, D–50672 Köln
**www.taschen.com**

Original edition: © 1999 Benedikt Taschen Verlag GmbH
Editing and layout:
Petra Lamers-Schütze, Kathrin Jacobsen, Cologne
Cover design: Sense/Net, Andy Disl and Birgit Eichwede, Cologne
English translation: Fiona Elliott

Printed in China
ISBN 978-3-8365-1355-5

# Content

# Apprenticeship and Youth in Florence

Remarkable, extraordinary, almost always favourable – that is the picture of Leonardo da Vinci handed down by the writers and critics of the past. They describe a multi-talented, endearing, attractive young man, who not only astonished his contemporaries as a visual artist, but was equally impressive as a scientist and a musician. While it was widely known that he also had other characteristics which might have caused concern in those days, for already as a young man he was reputed to have homosexual inclinations (Beltrami, nos 8–9) – a criminal offence at the time – by the 16th century these were accepted almost as a matter of course as part of his make-up as a genius (Lomazzo, I, p. 104). The only thing that people really held against him was his tendency to start works but not to finish them. Again and again his biographers bemoan the breadth of his interests because of the consequences this multitude of interests had for his art: "But while he was spending time on his researches in areas that are no more than of passing interest to art, his inconstancy and unreliability meant that he finished very few of his works; his talent strove so strongly for perfection and he was so demanding of himself, that he started numerous things but then cast them aside again" (Chastel, p. 72) – as reported by the humanist Paolo Giovio in his 1527 collection of lives of famous men, which also included other artists such as Michelangelo and Raphael. Giorgio Vasari made similar comments in his *Lives of the Artists* which first appeared in 1550: "He would have been very proficient at his early lessons if he had not been so volatile and unstable; for he was always setting himself to learn many things only to abandon them almost immediately."

Born on 15 April 1452 in Vinci not far from Empoli, it seems likely that the young Leonardo's early signs of intellectual ability and artistic talent were the reason that he was sent to become an apprentice to the Florentine painter and sculptor Andrea del Verrocchio (1433–1485). His first biographers make frequent reference to the young artist's outstanding facility in the art of drawing, for instance in Vasari's account: "Besides this, Leonardo did beautiful and detailed drawings on paper which are unrivalled for the perfection of their finish. (I have an example of a superb head in coloured silverpoint.)" Vasari also reports – admittedly only anecdotally – on the beginning of Leonardo's career as an artist: his father, ser Piero, "one day took some of Leonardo's drawings along to Andrea del Verrocchio (who was a close friend of his) and earnestly

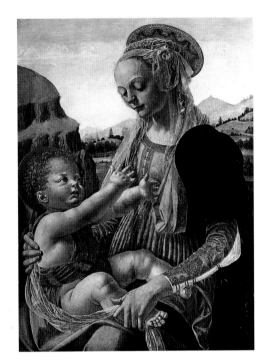

Andrea del Verrocchio
***Madonna and Child***, c. 1473–1475
Tempera on wood, 72 x 53 cm
Berlin, Gemäldegalerie, Staatliche Museen zu Berlin – Preußischer Kulturbesitz

Leonardo later developed this type of Madonna and Child in his own drawings and paintings.

PAGE 6:
***Madonna with the Carnation***, c. 1475
Oil on wood, 62 x 47.5 cm
Munich, Alte Pinakothek

This Madonna is regarded as the earliest extant painting entirely in Leonardo's hand. There are strikingly clear formal parallels to Dutch painting and to the Madonnas that came from the workshop of Andrea del Verrocchio.

**Portrait of the Executed Bernardo di Bandino Baroncelli,** 1479
Pen and ink, 192 x 78 mm
Bayonne, Musée Bonnat

On 29 December 1479 Leonardo made this portrait of Baroncelli who was condemned to death for his part in the Pazzi conspiracy. Leonardo probably hoped to paint an apotropaic image of the miscreant after the execution, and to this end made notes of the colours of the conspirator's clothes.

PAGE 9:
**Antique Warrior,** c. 1472
Metalpoint on prepared paper, 285 x 207 mm
London, British Museum

This drawing shows a particular type (the so-called 'old warrior type') which Leonardo adopted from the repertoire of his teacher Verrocchio and which he used frequently later on.

begged him to say whether it would be profitable for the boy to study design. Andrea was amazed to see what extraordinary beginnings Leonardo had made and he urged ser Piero to make him study the subject. So ser Piero arranged for Leonardo to enter Andrea's workshop. The boy was delighted with this decision, and he began to practise not only one branch of the arts but all the branches in which design plays a part."

This tale of the young genius who had already mastered the rudiments of his future métier even before he became an apprentice is of course part of art-historical legend; similarly the story of the close friendship between Leonardo's father and his future teacher Verrocchio may have been somewhat embellished. Yet the young Leonardo does seem to have displayed extraordinary talent as a draughtsman at a very early age. No other artist of his generation left behind such an extensive, authenticated wealth of graphic works. Even his earliest extant works from the 1470s demonstrate that talent in metalpoint and with the quill which his biographers were already referring to anecdotally in the 16th century. Typical of his sheer pleasure in drawing are the small, almost whimsical sketches of figures in motion, executed with short, energetic strokes of the pen. Alongside recognisable images there are freer exercises allowing his unique 'graphic' imagination to come into play. At the same time, other drawings from his early years demonstrate the disciplined attention to detail which all artists have to strive for during their training. This is particularly noticeable in the drawing of a lily (illus. p. 14), which was clearly a study for a painting. It is equally evident in the metalpoint drawing of a warrior from ancient times (illus. p. 9): this conforms to a particular type favoured in his master Verrocchio's workshop, which in turn drew on the models of Antiquity. It may well be that young artists such as Leonardo practised their skills using just such models. And indeed, at one point in his later *Treatise on Painting* (fol. 34) Leonardo advises artists to practise drawing by studying good reliefs and sculptures.

Leonardo's early, meticulous studies of draperies also give the impression of having been drawn from life. This is confirmed by Vasari's account: "... and as he intended to be a painter by profession he carefully studied drawing from life. Sometimes he made clay models, draping the figures with rags dipped in plaster, and then drawing them painstakingly on fine Rheims cloth or prepared linen. These drawings were done in black and white with the point of the brush, and the results were marvellous..." These carefully executed drawings served the artist both as studies and as a guide for the draperies in later paintings. Since they were in a sense models, these drawings were carried out with the greatest possible attention to detail in various techniques, often on durable linen, so that the next generation of young artists could learn from them (illus. p. 15).

Besides studies of the models usually found in artists' workshops, Leonardo also made equally important studies from nature. These are typified by the work he produced even when he was still an apprentice, such as his earliest extant dated drawing, now in the Uffizi in Florence. In the upper left corner, in his own characteristic mirror-writing, are the words "on the day of St. Maria of the Snow Miracle 5 August 1473" (illus. p. 10). This study in pen and ink over a barely visible preparatory outline shows a view of a valley with hills to either side, the horizon in the distance, and – with a small effort of imagination – the sea. Probably first sketched in pencil in the open air and then reworked with pen and ink in the

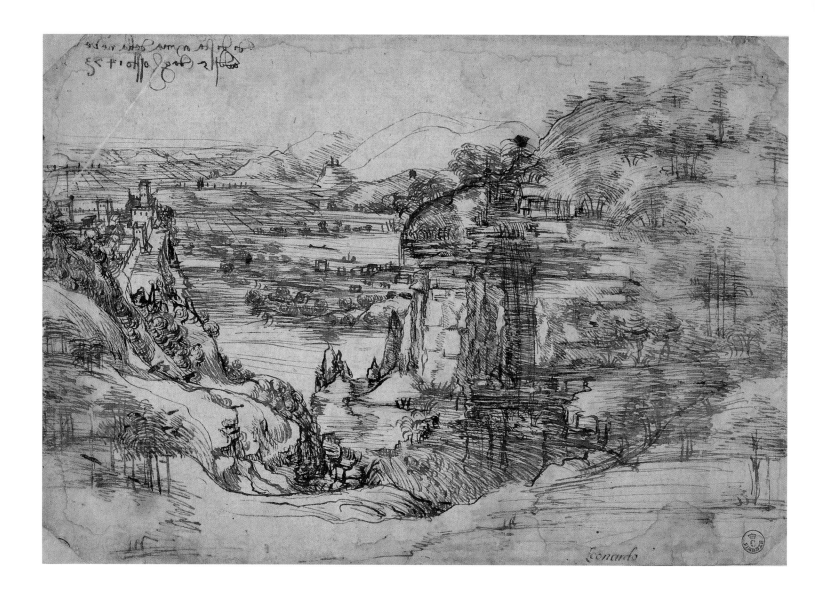

workshop, the view may well show a path leading from Vinci to Pistoia. In the early 20th century Woldemar von Seidlitz (I, p. 38) even felt he could identify the fortifications of Papiano in the walls and towers on a hillside on the left of the composition. This drawing, which counts as one of the earliest autonomous landscape sketches in art history, not only bears witness to the increasing importance of studies from nature in the 15th century, but also demonstrates the efforts artists were making to subordinate the features of the visible world to their own creative will. Thus, for instance, the crowns of individual trees on the hill on the right are simply sketched in schematically with rapid cross-hatchings. In places these crosshatchings combine to form oscillating patterns that go well beyond the immediate imitation of nature.

Leonardo's studies from nature and from life were of direct practical use in his paintings. Almost every painting required a landscape in the background, in many others painters had to portray draperies and fabrics, and very frequently, of course, they had to depict garments worn by the Virgin Mary and the angels. If we are to believe the anecdotes passed on by Vasari, one of Leonardo's earliest painted works was of just such a draped figure. Vasari reports the following circumstances regarding the painting, the *Baptism of Christ* (illus. p. 11), for which Andrea del Verrocchio had already done the main work: "Leonardo painted an angel who was holding some garments; and despite his youth, he executed it in such a manner that his angel was far better than the figures painted by Andrea. This was the rea-

*Arno Landscape,* 1473
Pen and ink over a partially erased pencil sketch, 190 x 285 mm
Florence, Uffizi

This pen and ink drawing is regarded as one of the earliest ever autonomous representations of landscape.

PAGE 11:
Andrea del Verrocchio and Leonardo
*The Baptism of Christ,* c. 1472–1475
Oil and tempera on wood, 177 x 151 cm
Florence, Uffizi

Leonardo assisted his master Verrocchio on this altar-piece, painting the angel kneeling at the far left, and repainting parts of the landscape and the body of Christ.

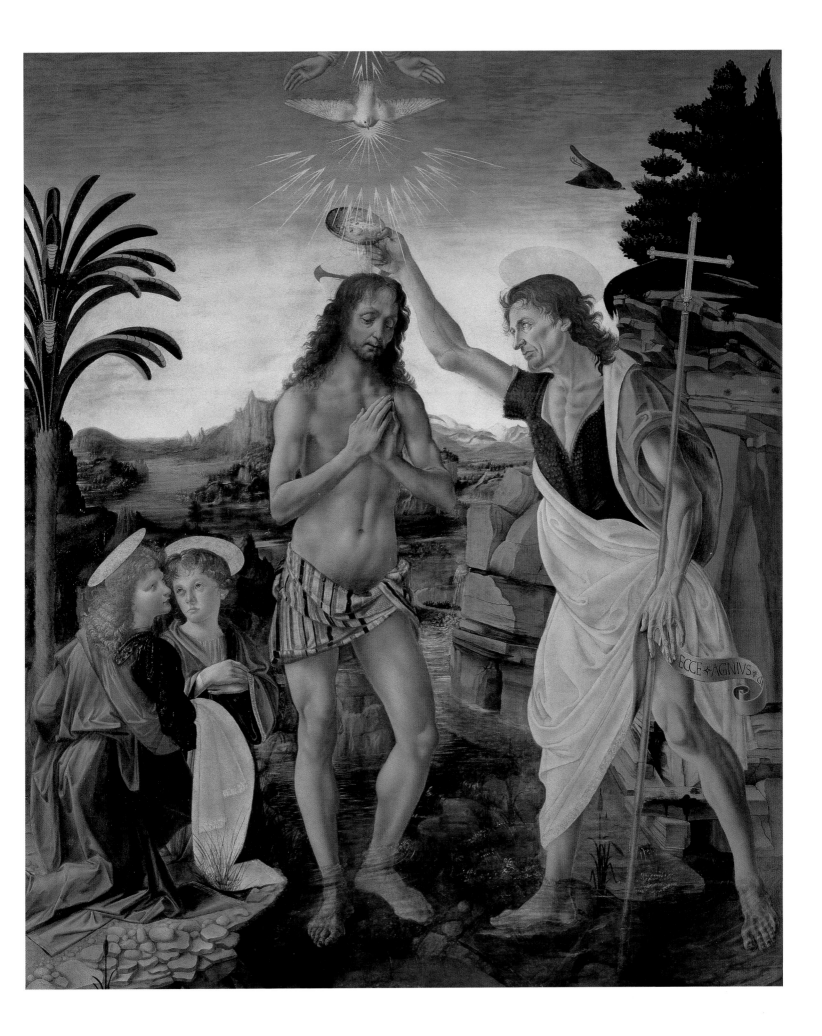

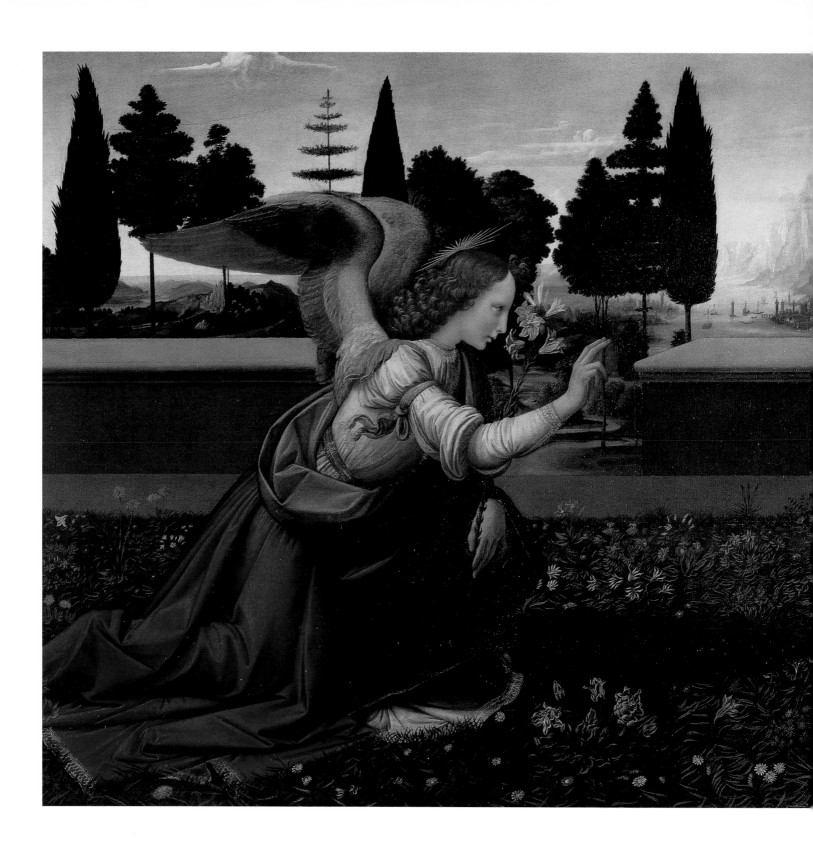

***The Annunciation,*** c. 1472–1475
Oil and tempera on wood, 78 x 219 cm
Florence, Uffizi

The attribution of this work to Leonardo is
controversial. However, it is generally accepted
that the overall composition, the figure of the
angel and the landscape are his. Several areas of
the picture, the angel's wings for instance, have
been repainted by another hand.

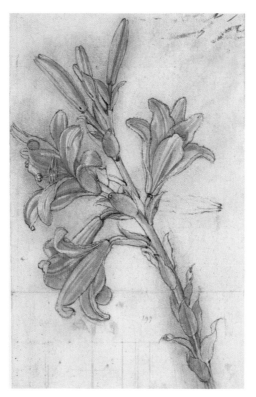

*Angel,* Detail from *The Annunciation*

*Lily* (detail), c. 1480–1485
Pen and ink over black chalk, 314 x 177 mm
Windsor, Windsor Castle

This drawing bears the typical marks of a
preparatory sketch: the contours of the lily have
been pricked so that it could be transferred
accurately to another surface. A similar drawing
must also have existed for the painting of the
Annunciation.

son why Andrea would never touch colours again, he was so ashamed that a boy
understood their use better than he did."

Of course while not every detail of this anecdote might withstand rigorous
examination, nevertheless the bold assertion that Andrea del Verrocchio gave up
painting after this collaboration with his pupil is perhaps not all that far-fetched.
There are in fact scarcely any paintings that can be attributed to Verrocchio after
the painting of the *Baptism of Christ.* Is it really possible that the master stood
aside in favour of his pupil? New investigations, however, provide rather more
conclusive results than mere anecdote, showing that the angel on the left edge of
the picture is indeed different in its technique and style to the figures by Verroc-
chio. Even before this, various commentators had already pointed out that the
position of the kneeling angel would seem to anticipate motifs of figures in
motion which are regarded as typical of Leonardo: the rotation of the upper body
contrasts with the way the head is turned, the movement of the left elbow is con-
tinued in the position of the right upper arm. In addition, the gentle shading of the
skin-tones in the face of the angel are distinctly different from the harder style
usually found in Verrocchio's work. Similar observations may be made on the
strength of investigations into the technique used for the central figure of the
painting: the body of Christ was evidently reworked in oils at a later stage, with
the result that the shading of the skin seems softer than that on the body of John
the Baptist painted by Verrocchio using tempera.

Thus, while the angel at the left edge of the picture and the reworking of the
figure of Christ may largely be attributed to Leonardo, the overall composition of
this altar painting and most of its details are by Andrea del Verrocchio alone. The
artist was guided in these partly by the descriptions of the Baptism of Christ in the
Gospels (Matthew 3.3–17; Mark 1.9–11) but mainly by older pictorial conventions:
Christ, who has removed most of his clothes, is standing on the stony river-bed of
the Jordan and is being baptised by John on his right. Above him hovers the dove of
the Holy Spirit, beyond this we see the hands of God the Father. At the left side of

the picture one of the two angels holds Christ's robe, and a palm in the background closes off the pictorial space. The somewhat schematic palm – in its role here as the tree of paradise symbolising salvation and life – seems archaic in its appearance. In marked contrast to this archaism – which underlines the symbolic character of the tree – are various other painterly elements of this composition, in themselves typical of many paintings by Leonardo. The landscape, which also shows signs of having been reworked a number of times by the younger painter, stretches in an apparently wholly natural manner throughout the entire depth of the picture. Clear waters play around precipitous cliffs, a warm light spreads from the left across the group of figures in the foreground, dramatically cleft mountains contrast with the smooth expanse of water and fade in the distance into a soft blur; directly above the horizon the blue of the sky lightens until it becomes a gleaming white.

The *Baptism of Christ* is a demonstration of artistic independence and dependence at one and the same time. While the reworkings by Leonardo already point to an independent artistic personality, the actual circumstances of the young painter in the mid–1470s would seem to indicate that he was, to a degree, still dependent on his master and the latter's workshop. At this time, when he could long have been independent, Leonardo was in fact still living under Verrocchio's roof. Therefore it is hardly surprising, that almost all the early paintings attributed to Leonardo, are to an extent indebted in their appearance to the works of his master. This applies, amongst others, to the *Annunciation* in the Uffizi in Florence (illus. p. 12–13). The rich ornament of the decorative sarcophagus placed before Mary, for instance, has much in common with a similar work that Andrea del Verrocchio finished in 1472 for the Old Sacristy in the Church of S. Lorenzo in Florence.

In his design for this large painting Leonardo drew mainly on the pictorial conventions of the 15th century: the Archangel Gabriel is kneeling in the garden of the Virgin (Pseudepigrapha Jacob 11; Luke 1.26–38) who receives his news sitting at her reading desk, and learns that she has been chosen to bear the Son of God. The scene is flanked to the right by relatively contemporary architecture, the middle ground is closed off by a low wall reaching to about knee-height with a small opening in it. This opening – which serves as a background to the gesture of greeting by Gabriel and the lily in his left hand (a symbol of Mary's purity) – also reveals a path disappearing into the distance. The furthest most point of the scene is marked by the sharp silhouettes of a small wood and mountains in the distance against the glowing sky.

*Study for the Arm of an Annunciation Angel,*
c. 1472–1475. Pen and ink, 75 x 92 mm
Oxford, The Governing Body, Christ Church

This small drawing is a study for the angel in the Annunciation attributed to Leonardo in the Uffizi.

*Drapery Study for an Annunciation Angel,*
c. 1474. Brush and grey tempera heightened with white on grounded grey linen,
182 x 233 mm
Paris, Musée du Louvre

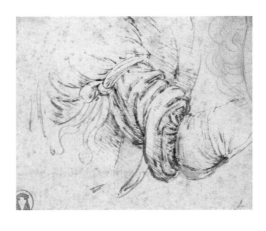
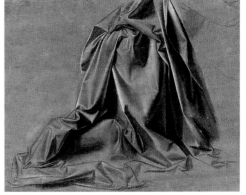

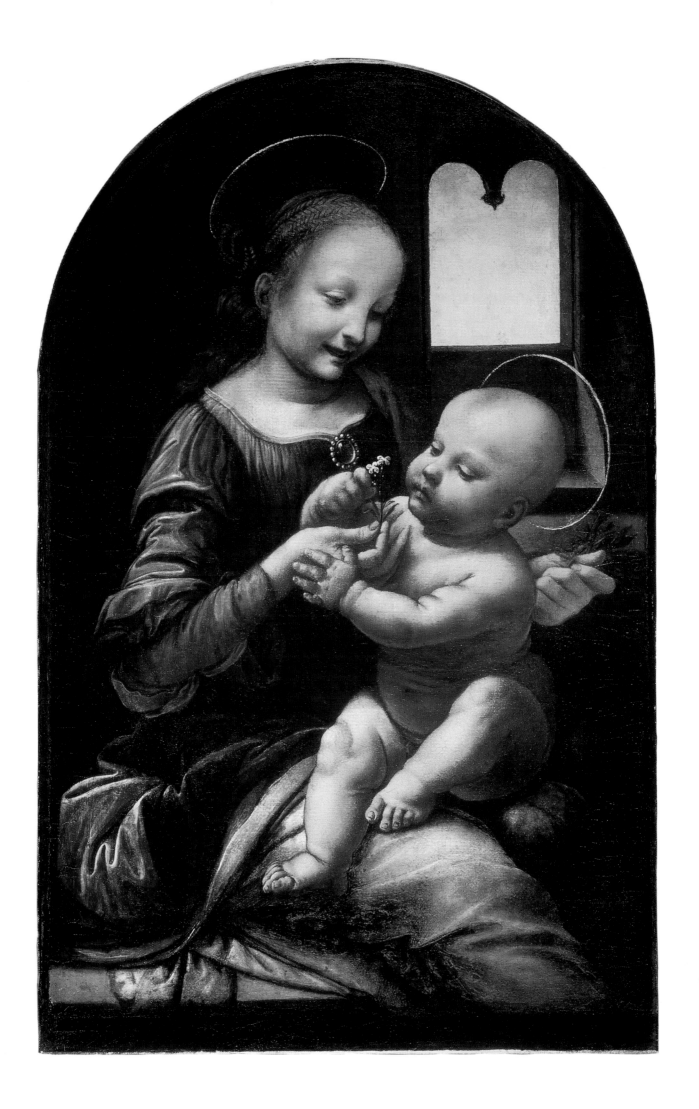

There is by no means unanimous agreement on the attribution of this painting of the Annunciation to Leonardo. There is only agreement that the lengthways composition, the Archangel Gabriel and parts of the landscape are the work of Leonardo – and, in fact, a study by Leonardo for the right arm of the angel has survived to this day (illus. p.15). Similarly the mountains fading bluely into the morning mists in the background are distinctly reminiscent of work by the young Leonardo in Florence, who was often to return to this theme in later works. Leonardo's touch is particularly evident in the masterly treatment of the elements, water, air and light, which become increasingly atmospherically dense around the steep foothills of the almost alpine ridges and peaks in the distance. Leonardo was later to describe similar phenomena in several passages in his *Treatise on Painting*: "Such horizons in painting are most beautiful to see. Of course to either side there must be some layerings of mountains, as the diminution of colours in great distances demands" (fol. 283v).

Evidence of Leonardo's close attachment to his master is also to be found in the small Madonna, which is regarded as his first independent work, the so-called *Madonna with the Carnation* in the Alte Pinakothek in Munich (illus. p.6). Most likely painted during his time with Verrocchio, in this work – with its small columns in the middle-ground and landscape in the background – Leonardo is drawing on aspects of works by the Old Dutch Masters. The figures of the Madonna and the infant Jesus, on the other hand, clearly pay allegiance to the pictorial forms favoured in Verrocchio's workshop. Such Madonnas, intended for domestic use and private worship, were found widely in 15th century Florence. Besides portraying the loving relationship of Mary and the infant Jesus, Leonardo also includes symbols of customary elements of Christian belief: in an unpractised gesture the Holy Child reaches out with his little hands for a red carnation, the symbol of the Passion of Christ, pointing in this depiction of childlike innocence to the later Crucifixion awaiting the Saviour. Equally important for its symbolism is the crystal vase filled with flowers at the right lower edge of the painting, an unmistakable indication of the purity and virginity of Mary. At the same time, motifs such as the carnation and the crystal vase, which demand great skill on the part of the artist, allowed Leonardo to give an impressive demonstration of his talent, as also in the masterly fall of the fabric across the Madonna's lap, with its intense coloration that gives life to the deeply shaded and otherwise undynamic foreground.

Occasionally Leonardo made short inventories of the works in his possession. From these we can tell that during his first years in Florence he made several small pictures of the Madonna. This is not only borne out by the few surviving works but also by a number of sketches (illus. p.17). In these sketches there are clear signs of the young painter's urge to test out – within the limits of convention – the possibilities of movement and expression. At the same time, however, there are also experiments in pure flights of fancy which, using the medium of drawing, take liberties of completely free artistic expression not permissible in paintings.

The influence of Flemish style and pictorial forms, which may be seen in Leonardo's *Madonna with the Carnation* and in his later *Adoration of the Magi* (illus. p.25) is seen at its most striking in the *Portrait of Ginevra de'Benci* (illus. p.19). This portrait is the first fixed point of reference in the œuvre of Leonardo the painter: it is the earliest extant work for which we have reliable documentation and information. Much more than his religious paintings so far, it breaks away from the

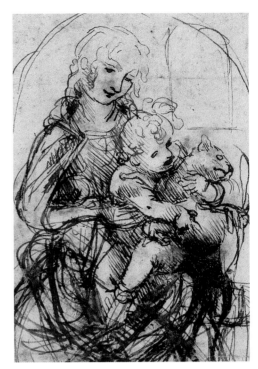

***Virgin and Child with a Cat,*** c. 1480
Pen and ink over pencil sketch, 132 x 95 mm
London, British Museum

PAGE 16:
***Madonna Benois,*** c. 1475–1478
Oil on canvas (transferred from panel),
48 x 31 cm
St. Petersburg, Hermitage

This painting, named after one of its former owners, is distinct from figures of the Madonna by other artists by virtue of its darker colours, the subtlety of the light and that particular degree of movement which is also seen in Leonardo's sketches for the same subject.

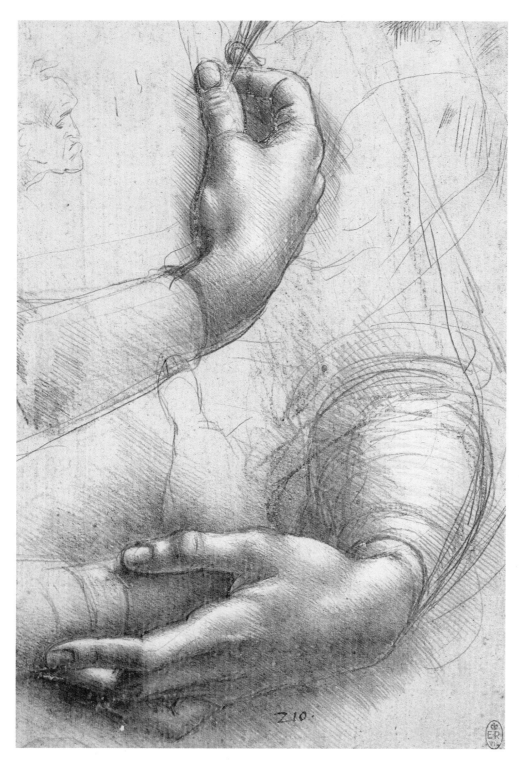

*Study of Arms and Hands,* c. 1474
Silverpoint heightened with white on pink
prepared paper, 214 x 150 mm
Windsor, Windsor Castle

Leonardo probably carried out studies of this
kind in connection with portraits he was plan-
ning.

pictorial conventions of the Verrocchio workshop – not least in the fact that it is
his first secular painting. The most remarkable feature of this small portrait is the
closely packed distribution of the pictorial space. The young woman, Ginevra
de'Benci, close to the front edge of the picture, is sitting in front of a juniper
bush, which seems to surround her head like a wreath and obliterates a large part
of the background. Comparable 'close-ups' were already to be found in Flemish
portraits, as first painted by Jan van Eyck a generation earlier and popularised by
Hans Memling. Similarly, the format – cut off at the lower edge – and the very
natural appearance of the juniper plus the position of the figure are all reminiscent
of earlier Flemish portraits. The young woman's upper body, virtually diagonal to
the picture surface, contrasts with her head which is turned almost completely
towards the viewer, with the result that – despite her rather listless expression –
she does radiate a certain dynamism. It is perhaps worth noting that Ginevra's

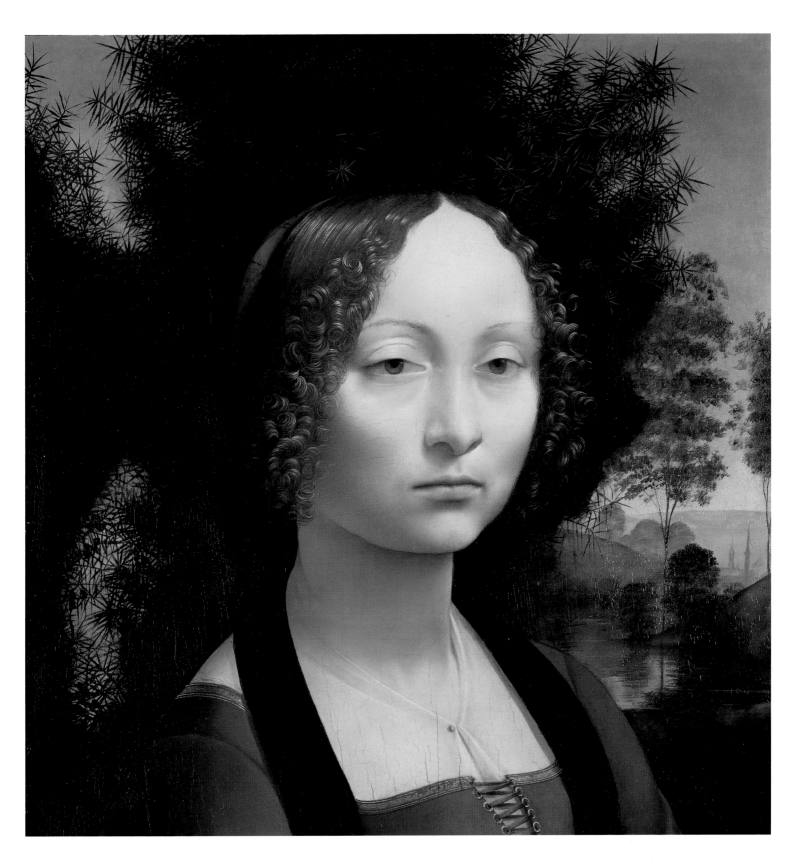

***Portrait of Ginevra de'Benci,*** c. 1478–1480
Oil and tempera on wood, 38.1 x 37 cm
Washington, National Gallery
Ailsa Mellon Bruce Fund
© 1998 Board of Trustees

This portrait, showing the influence of the Old
Dutch Masters in its style and technique as well as
in the meticulous portrayal of nature, demonstrates
the connection between female beauty and virtue.
The panel has been cut at the lower edge where
Ginevra's hands might once have been.

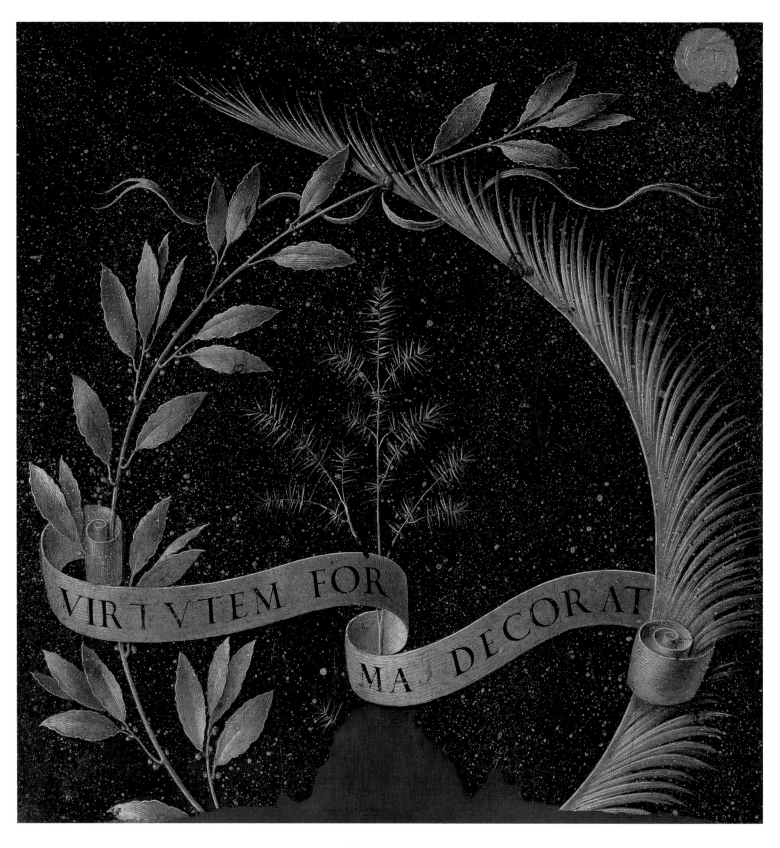

***Portrait of Ginevra de' Benci,*** reverse

The painted reverse of the portrait continues the
theme of the front, with the inscription spelling
out the connection between virtue and beauty:
"Beauty adorns Virtue".

interesting pallor is not determined by artistic considerations but a symptom of a sickly constitution as some sources would have it.

The juniper in the middle-ground indubitably dominates the portrait of Ginevra and is more than an ornamental accessory, for – like certain other plants – the juniper was a symbol of female virtue. Furthermore, the Italian name 'ginepro' was not unrelated to the name of the sitter, Ginevra. There is a complex sequel to these allusions on the reverse of the portrait which is, unusually, also painted. There, on imitation red porphyry marble, we see laurel, juniper and palm branches linked to each other by a swirling garland with the words VIRTUTEM FORMA DECORAT: 'Beauty adorns Virtue'. The inscription, the plant-attributes and the painted marble all underline the connection between beauty and virtue. With its imitation of red, immensely durable porphyry marble – in itself a remarkable substance – the reverse of the portrait speaks of the resilience of Ginevra's virtue. The laurel branches and palm fronds, framing the garland with its inscription, are associated with Bernardo Bembo who commissioned the painting, for both featured in his own personal arms. The juniper in the centre, growing from the garland, is yet another allusion to Ginevra's name and the virtues of chastity and faithfulness. At the same time the evergreen laurel points to Ginevra's aspirations as a poet, which we know of from Bembo and other writers. The palm frond, too, is a traditional symbol of virtue. The inscription VIRTUTEM FORMA DECO-RAT, so closely intertwined with the plants as symbols of virtue, makes the connection between beauty and virtue, which was a topos of contemporary literature reflected here on the front of this portrait, where Ginevra's gentle beauty is also to be understood as an expression of her virtue. The front and the reverse of this portrait could hardly be linked more closely.

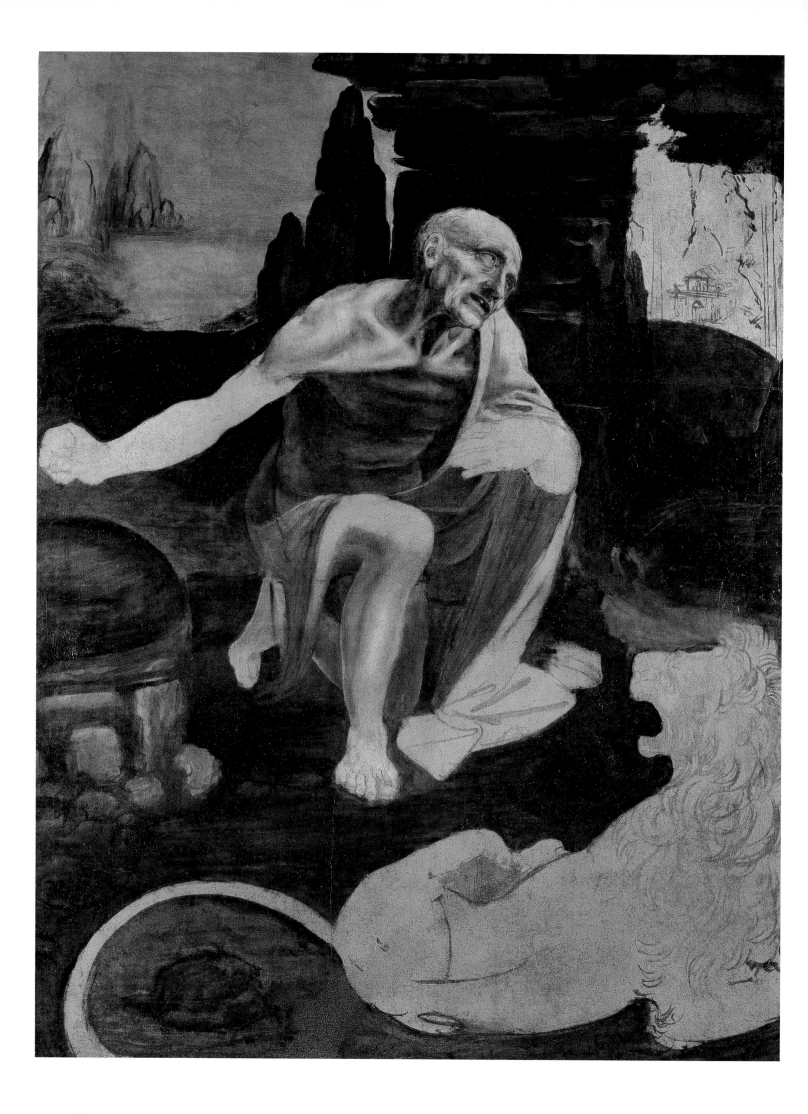

# Beginnings without Ends

Leonardo's early paintings would seem to indicate that he was only receiving small-scale commissions at the time. Clearly it was not easy for the young artist to make his mark on the Florentine art-market, and it is true that there was no shortage of good painters: Antonio del Pollaiuolo shone brightly with his important commissions, Sandro Botticelli was just approaching the highpoint of his career, and Domenico Ghirlandajo, Michelangelo's teacher, was already running an extensive, highly successful workshop. In the face of competition like this obviously talent alone was not enough: good personal connections were vital (as helpful to professional advancement then as they are today). The year 1478 saw his first attempts to secure larger-scale commissions through personal recommendation, and he was indeed commissioned that year to paint an altar-piece for the Bernhard Chapel in the Palazzo Vecchio, the seat of government in Florence. It is likely that Leonardo's father played a part in this, for by now the latter had made a considerable reputation in Florence as a successful notary and had already done a certain amount of work for the 'Signoria' (the Town Council). Yet, even although the artist received a generous advance of 25 gold ducats three months after the contract was signed, he never finished the painting (Beltrami, nos 10–11).

Even if Leonardo perhaps never even started the painting for the Bernhard Chapel, by the late 1470s he seems to have gradually established himself as a painter. This was probably when he started the medium sized altar painting with St. Hieronymus. This picture, which has somewhat suffered the ravages of time, was never finished but nonetheless allows us to see an approximation of Leonardo's original intention. The saint is portrayed as a penitent in the desert, here indicated as a barren landscape with smallish rock formations. With his suffering showing in his face, St. Hieronymus is kneeling almost exactly in the centre of the pictorial space. His left hand touches the seam of his open robe while his right hand grasps a stone and is drawn right back in preparation for a blow. On his emaciated, bony chest there is a dark patch in the region of his heart - in all likelihood a blood-soaked wound which the saint has inflicted on himself during his penance. A lion with his mouth wide open, lying immediately in front of Hieronymus - his pet and his attribute, for once he had pulled a thorn out of the lion's paw – seems to be watching the proceedings. It is just possible to see that in fact the saint himself is looking towards a crucifix placed parallel to the right-hand picture edge. Thus a link is created between his own suffering as a penitent, the Crucifixion, and the suffering of the Saviour.

***Kneeling Angel,*** c. 1480
Pen and ink, 125 x 60 mm
London, British Museum

This lively pen sketch goes back to the so-called models of 'kneeling figures' used for drawing practice in artists' workshops.

PAGE 22:
***St. Hieronymus,*** c. 1480–1482
Oil on wood, 103 x 75 cm
Rome, Pinacoteca Vaticana

This panel, probably painted for the altarpiece for the Badia in Florence, remained unfinished. It shows St. Hieronymus as a penitent in the desert.

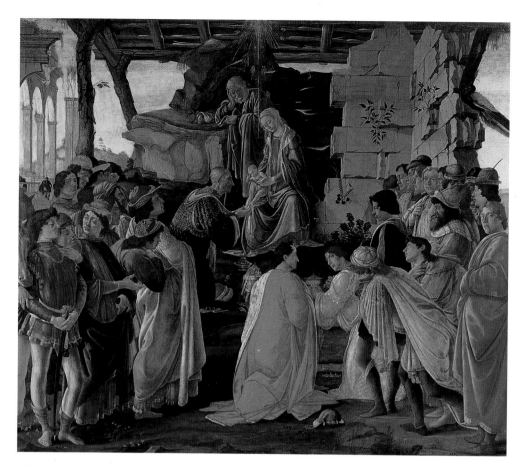

Sandro Botticelli
**Adoration of the Magi for Gaspare del Lama,** c. 1472–1475
Tempera on wood, 111 x 134 cm
Florence, Uffizi

The arrangement of the figures in the foreground may well have been an inspiration for Leonardo's own *Adoration of the Magi.*

In his depiction of Hieronymus, Leonardo was giving form to artistic ideas which he was to return to in greater detail in later years in terms of art theory and 'science'. In formal terms, the figure conforms to the simplest type of pose studied at the time in artists' workshops, namely the so-called kneeling figure. Painters' apprentices would use clay or wooden figures in the relevant pose as models for their drawing exercises. Besides this, in this portrayal of Hieronymus, Leonardo also gave form to wider ideas: the suffering facial expression of the saint reflects contemporary notions of physiognomy and physiology, which the artist was later to record in his notes and develop yet further. Furthermore, the musculature and sinews of the shoulder may be taken as an early indication of Leonardo's interest in the outer appearance of the human anatomy.

It seems probable that Leonardo received his most important commission to date while he was still working on his *St. Hieronymus*: he was asked to paint a large panel with an 'Adoration' scene for the high altar in San Donato a Scopeto, the church attached to an Augustine monastery outside the city gates. The importance of this commission could well have been the direct cause of the artist leaving the smaller Hieronymus panel unfinished. Leonardo's father, who administered the monastery's business affairs, may have been instrumental in setting up the commission for an 'Adoration' in March 1481 (Beltrami, no. 16). The fact that a year later Leonardo left this painting unfinished, too, may well have been due to his move to Milan.

Despite its unfinished state, the main features of the composition of the almost square *Adoration* are clearly identifiable. Mary with the infant Jesus is seated in the centre foreground in front of a barren, rocky rise, out of which two trees are growing. The three kings who followed the Star of Bethlehem on their journey

**Figure Studies for an Adoration,** c. 1481
Pen and ink over metalpoint. Preparatory drawing on violet prepared paper,
173 x 111 mm
Hamburg, Hamburger Kunsthalle

Numerous studies – such as these with their almost playful moving figures – bear witness to the lengthy process Leonardo would go through when he was working on a painting.

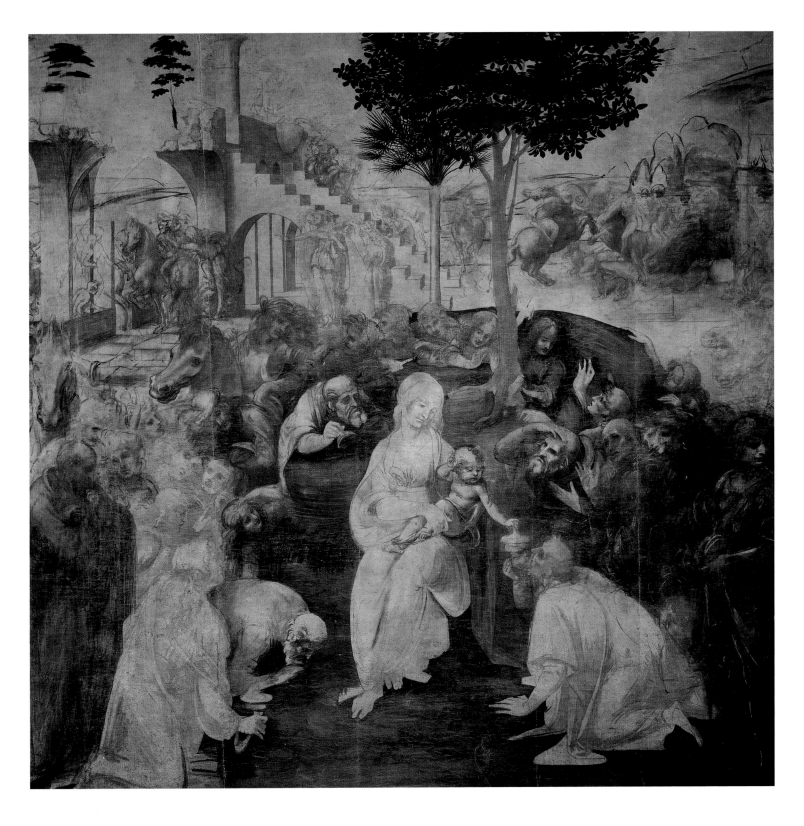

from the East worship before the Child sitting on his mother's lap. The first king, Caspar, is bowing low to the Mother and Child at the left. In the right foreground, the second king, probably Balthasar, has sunk to the ground in awe; the Child is blessing him as he offers his gift. Meanwhile the figure kneeling in the left front foreground, with his head raised, is most probably Melchior, the youngest of the three kings. In addition, numerous other figures are grouped in a semi-circle round the Madonna: these include Joseph (either in the figure of the old man at the far left of the picture or the old, bearded man behind the Madonna herself) and various members of the kings' entourages. There is a striking variety of movement and gesture amongst the figures in this composition. Most of the figures are entirely focused on the Mother and Child, while some are looking up towards the

*Adoration of the Magi*, 1481–1482
Oil on wood, 243 x 246 cm
Florence, Uffizi

When Leonardo moved to Milan in 1483 he left this altar panel – his most important work so far – unfinished in Florence. It shows the moment when the second king offers his gift of frankincense: traditionally a symbol of the Eucharist.

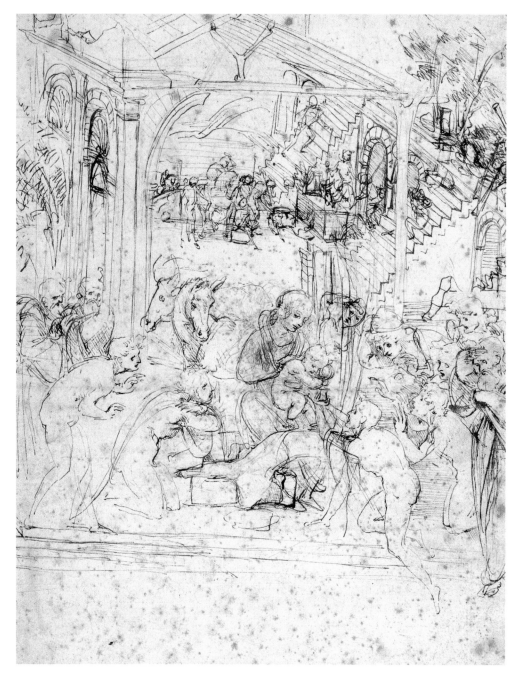

*Compositional Sketch for the Adoration of the Magi*, c. 1481
Pen and ink over metalpoint (?),
278 x 208 mm
Paris, Musée du Louvre

This sketch shows that the original composition of the *Adoration* was less complex than the final version.

sky, possibly at the Star of Bethlehem – as seen, for instance, in Sandro Botticelli's *Adoration* (illus. p. 24) painted only shortly before – and which Leonardo had intended to include in his own composition. As it happens, the semi-circular group of figures in the foreground is also inspired by his older colleague's depiction of the 'Adoration'.

While the figures in the foreground crowd around the Madonna and Child, the people and creatures from the kings' entourages are dispersed much more loosely in the background. As is often the case in representations of the 'Adoration', in the background we see the ruins of the palace of King David, alluding to an Old Testament ancestor of Christ. The two young trees growing in the ruin correspond to the two trees near the Madonna and Child, and may be read as symbols of a new era, a time of peace and mercy that was to follow the birth of Christ. The taller of the two trees in the middle-ground is clinging by its roots to the inhospitable surface of the rocky rise, with one of these roots apparently linking the tree itself and the head of the Christ Child. It is possible that this link is an illustration of the interpretation of the legend of the 'Adoration' as found at the time in the popular

*Legenda aurea*: here it was said that the kings had seen, in metaphorical terms, five stars rather than just one, and that the fifth – Christ himself – was to be interpreted as the "root and the tree of David" (ed. Benz, p. 108). Lastly, the two horses rearing up in the background, which look at first sight as though their riders must be in combat, may also be a reference to another medieval legend: according to this account, the three kings had at one time been bitter enemies. It was only after their miraculous journey and after having witnessed the Coming of Christ, the Saviour, that they made peace with each other, as did the whole of the rest of the world, too. The violent confrontation of the two horses in the background is an allusion to their former enmity, in itself in stark contrast to the era of peace portrayed in the image of worship in the foreground. With this division of the pictorial space into foreground and background, Leonardo draws a clear line between the time before the Advent of the Lord and the Age of Grace which began with the birth of Christ and His adoration by all peoples.

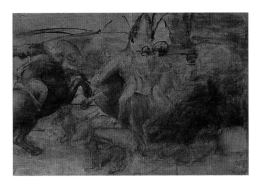

**Combat on Horseback,** Detail from the
**Adoration of the Magi**

This detail illustrates an event which took place during the journey of the three Kings.

**Perspective Study for the Background of the Adoration**, c. 1481
Pen and ink over metalpoint, 165 x 290 mm
Florence, Uffizi

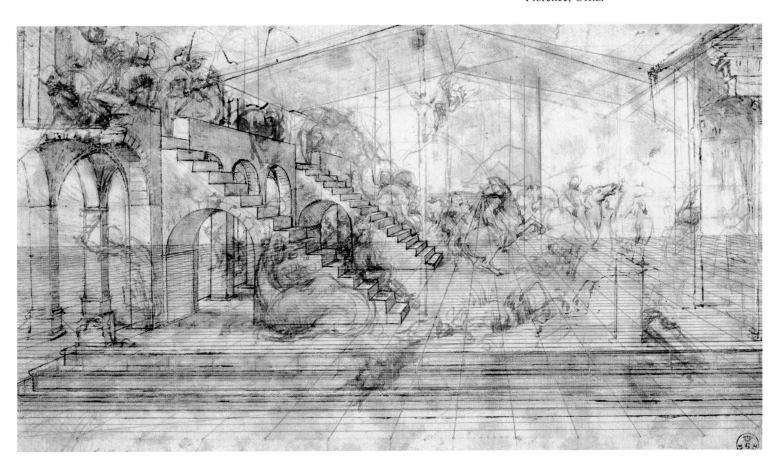

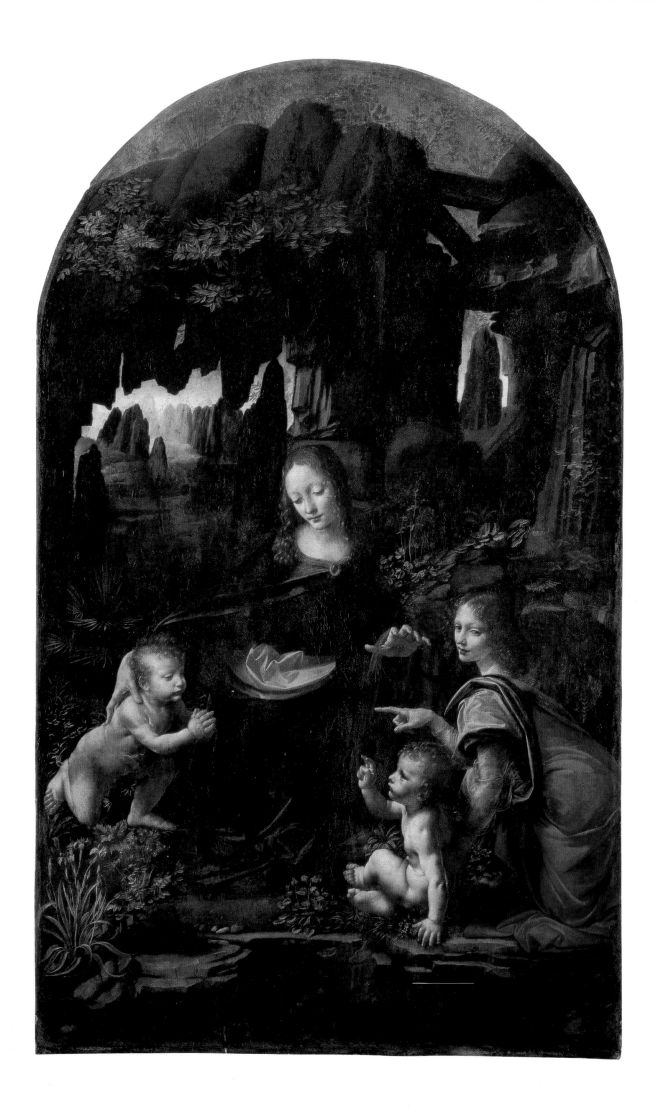

# New Artistic Departures in Milan

Leonardo had not finished his *Adoration* when he left his native town at roughly the age of thirty in late 1482 or early 1483 to make a new start as an artist in Milan. We can only guess at his reasons for leaving Florence. In view of Milan's status as one of the leading cities in Europe, presumably Leonardo hoped to secure more important commissions than had come his way in Florence. First and foremost amongst commissions for which he might bid in Milan was the proposal for a larger than life equestrian statue of Francesco Sforza put forward by Ludovico il Moro, the Governor of Milan. This project was intended by Ludovico both as a memorial to his father Francesco Sforza and to enhance his own reputation, and Leonardo refers specifically to it in his famous letter of application, which he probably sent to the court in Milan in 1482 or 1483. In this letter above all Leonardo stresses his talents as a military engineer, and only remarks in passing, as it were, that as a painter he could hold his own with any other artist. Clearly Leonardo felt his best hope of employment was as an engineer or military architect, since Ludovico Sforza, like other despots in those days, was constantly involved in military conflicts of all kinds.

Leonardo's wordy letter to Ludovico il Moro seems initially to have missed its mark because his first commission as an artist was not from the court of the Sforza family, but from the Franciscan Confraternity in the Church of S. Francesco Grande. The Confraternity commissioned Leonardo, along with two local artists, the de Predis brothers to paint a large altar-piece for their recently completed chapel, dedicated to the Feast of the Immaculate Conception of the Virgin Mary. The contract contained detailed instructions for the artists regarding the painting and gilding of the large altar retable which the joiner had already finished in 1482 (see drawing on p. 30). Leonardo painted the central panel, which has survived in two versions. The older of the two is in the Louvre in Paris while the second version is in the National Gallery in London (illus. p. 31). The side panels are also in the same gallery in London, with two angels making music painted by Leonardo's colleague Ambrogio de Predis. Several reliefs depicting scenes from the life of Mary plus prophets and God the Father up above complete the front of this monumental altar retable. A niche in the centre of the retable housed the actual devotional image of the Immaculate Conception: a wooden sculpture of the Madonna and Child. Leonardo's *Virgin of the Rocks* was then placed on a pulley in front of this niche, concealing the *Immacolata* – the sculpture of the Madonna and Child – for 364 days of the year. It was only on 8 December, the Feast Day of the Immaculate Conception, that Leonardo's painting was lowered mechanically,

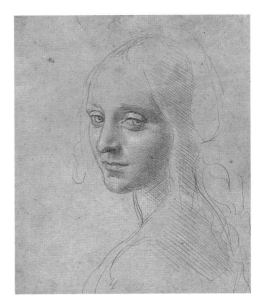

*Study for the Head of a Girl,* c. 1483
Silverpoint on brownish prepared paper,
182 x 159 mm
Turin, Biblioteca Reale

The movement of the girl's head and her smile served as models for the angel in the *Virgin of the Rocks.*

PAGE 28:
*The Virgin of the Rocks (Mary with Christ, the infant St. John and an angel),* 1483–1486
Oil on wood, 199 x 122 cm
Paris, Musée du Louvre

Leonardo's first painting in Milan was part of a large altar retable for the Franciscan Confraternity of the Immaculate Conception.

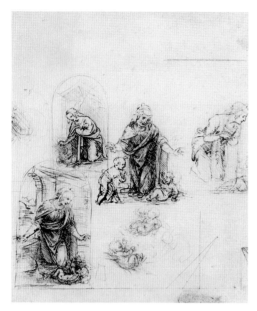

*Studies and sketches, probably for the Virgin of the Rocks,* c. 1483
Pen and ink over preparatory pencil drawing, 195 x 162 mm
New York, The Metropolitan Museum of Art

*Reconstruction drawing of the altar retable with the Virgin of the Rocks*
(Malaguzzi-Valeri)

The *Virgin of the Rocks* formed the central panel of a large altar retable. It was flanked by two pictures of angels. The decorations were completed with reliefs depicting stories from the life of Mary and sculptures of the prophets.

revealing the devotional sculpture, so that it might be worshipped directly. Thus it seems that Leonardo's *Virgin of the Rocks* was in fact a 'screen painting' behind which the actual devotional image was concealed.

Leonardo portrayed the Virgin Mary together with the infant St. John, Christ and an angel either in, or in front of, a rocky grotto – hence the title by which we know it today, the *Virgin of the Rocks*. The very youthful Mary, in a dark blue garment, is sitting or kneeling almost exactly in the centre of the composition. She is gazing gently down towards the infant St. John who is engaged in prayer; she has her right hand around his shoulders, while her left hand is raised protectively above the figure of Jesus. To one side of the scene is an angel, most probably Uriel who – in the Paris version at least – gazes out of the picture with a quiet smile, establishing contact with the viewer (illus. p. 28). With his right hand, as John's guardian angel, Uriel is pointing towards the child whose hands are clasped in prayer, with his left hand he is supporting the infant Jesus sitting in front of him, who is also turned towards John, raising one hand in blessing. Thus the figures are interconnected by a rich pattern of glances and gestures, with the viewer drawn into the whole by the figure of the angel.

In both versions of the *Virgin of the Rocks* it seems that the rocky, stony ground falls away sharply in the foreground. This immediately makes it clear that the location is somehow distant and secluded, and this is further emphasised by the wildly rugged rock formations in the middle and background. In several places we can see through to water and a mountain landscape shrouded in light and mist. In addition, in the Paris version, there is a broad area of blue sky closing off the top of the composition. The radiance of the background, the shimmering of the water and the plants here and there soften the inhospitable atmosphere of the rocky location. This effect is continued in the light entering in the left foreground. Some of these elements may be read as religious symbols: the water and the pearls and the crystal which are used to fasten Mary's robe may all be taken as symbols of her purity. This in itself would make the connection with the immaculate conception of Mary, to whom the chapel of the *Virgin of the Rocks* was dedicated. The rock formations may possibly also be read in terms of Marian symbolism, alluding to similar topoi in prayers to the Virgin – and the same may well also apply to the later painting of the *Virgin and Child with St. Anne* (see pp. 64ff.). The Mother of God was regarded as the rock, not cleft by human hand, and the inhospitable stone formations, eroded by natural forces might therefore be interpreted as a metaphor for Mary, pointing to her unexpected fertility. In addition, the cleft rock was regarded as a safe refuge for the infant St. John and Christ.

In Leonardo's painting for the Confraternity of the Immaculate Conception, the infant St. John clearly has a particular role, and indeed his presence in the iconography of the painting is unusual. A meeting between John and Christ as infants is rare. No such meeting is recorded in the Bible itself, only in the so-called Books of the Apocrypha. These contain accounts of the flight into Egypt including descriptions of Mary and Jesus apparently meeting John in the wilderness. It is possible that the figures and the rather barren surrounding in Leonardo's painting go back to these accounts. The deeper meaning of this masterly portrayal of the meeting between John and Christ in hostile surroundings derives directly from the religious convictions of those commissioning the work. The Franciscan monks who commissioned the altar retable and the *Virgin of the Rocks* felt specially close

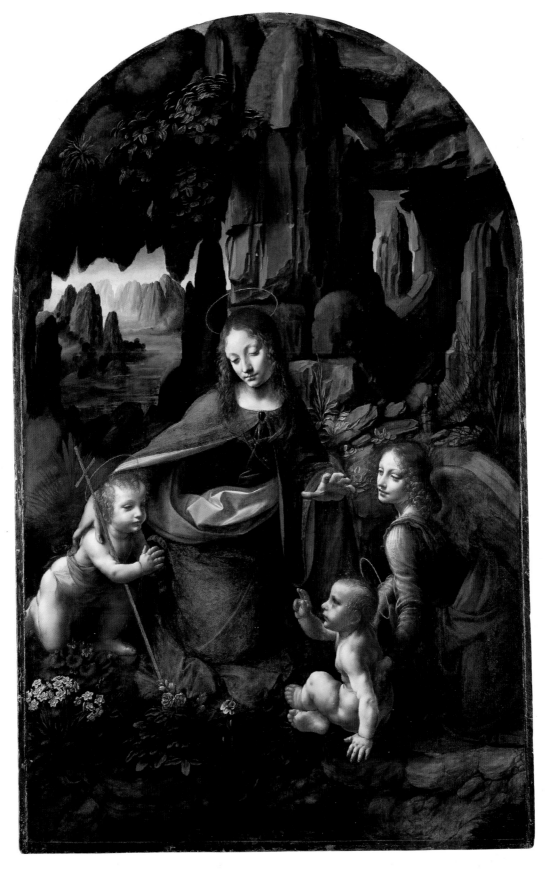

***The Virgin of the Rocks*** *(Mary with Christ,
the Infant St. John and an angel),*
c. 1493–1495 and 1506–1508
Oil on wood, 195.5 x 120 cm
London, National Gallery

In the second version of the *Virgin of the
Rocks*, which was made to replace the first
version after it was sold, Leonardo added the
halo and the staff of St. John.

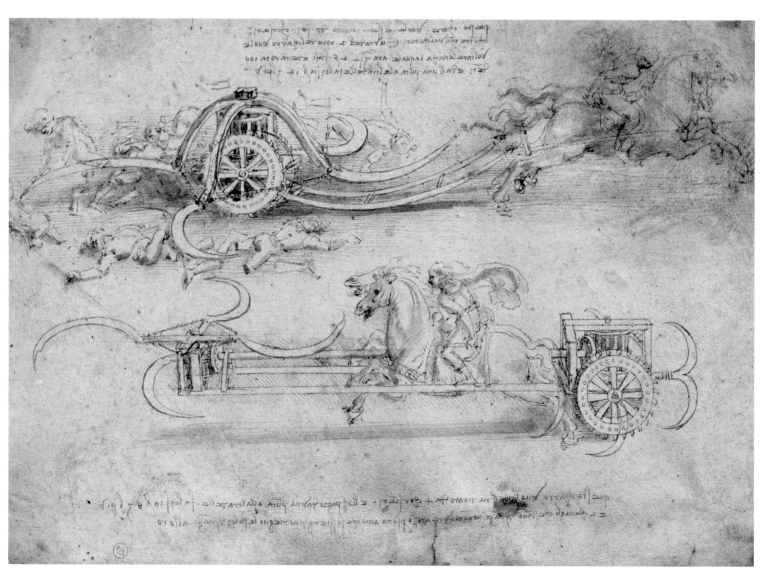

to Christ, St. Francis and John the Baptist. Thus they would have identified with the infant St. John worshipping Christ but also being blessed by Christ and in the care of the Virgin Mary. So, in this work the Confraternity was doubly present, as it were: once facing the picture as they performed their acts of worship and devotion, and once in the picture itself in the figure of St. John that had particular meaning for them. Moreover, Mary's hand and a section of her robe envelop John, showing that the child and, by implication, the Confraternity is under Mary's protection. The motif of protection is depicted both in Mary's robe round the child and in the location itself, for the rocky surroundings can be read as a metaphor for a safe haven. This might also explain the intense effort Leonardo put into the portrayal of the rocky background and the garments. Mary's robe is almost monumental in its dimensions and – certainly in the Paris version – seems to match Uriel's seemingly billowing garment. Similarly the surrounding landscape appears to be sheltering the figures in the foreground.

The harmonious composition and the masterly design of the *Virgin of the Rocks* of course give no hint of the irksome legal disputes that Leonardo and his two colleagues had to weather shortly after the work was completed. There was a bitterly complex disagreement about payment: the artists threatened to sell the work to an art-lover who had clearly offered them more than the Confraternity was prepared to pay. It was probably this dispute which led to the making of the second version of the *Virgin of the Rocks* – the version which is on view today in London and which in fact adorned the monks' chapel in San Francesco Grande in Milan during the 16th century (illus. p. 31). The older version (illus. p. 28) was most likely quickly acquired by an art-lover, possibly Ludovico Sforza, who then gave the picture either to the Emperor Maximilian or the King of France (see p. 81).

With the *Virgin of the Rocks* Leonardo had certainly established himself as a painter in Milan, but the hope of a position as court artist that he had expressed in his letter to Ludovico Sforza was not to be fulfilled until some years later. To this day we have virtually no information relating to professional activities Leonardo undertook to keep his head above water in the mid to late 1480s in Milan. All we know for certain is that he made designs for military devices and machines, some of which were positively fantastic. He drew weapons of all kinds, fortifications, complex defence systems, siege equipment and much more. Amongst the curiosities of this phase are the heavily armoured vehicles whose immense weight would have all but prevented them being moved forwards, or in any direction at all for that matter. Other ideas seem more immediately dangerous, such as his suggestion that the fire-power of small cannons could be increased by using multiple shot and an automated loading system. Positively gruesome are the horse-drawn carts equipped with scythes with which the enemy could literally have been mown down. Leonardo copied at least one device of this kind from a contemporary military treatise, Roberto Valtario's *De re militari* of 1472, and drew it several times. However, he accompanied this with a distinctly ironic written warning that this kind of equipment could do just as much damage to one's own troops as to those of the enemy.

Fortunately Leonardo did not restrict his skills as a draughtsman to military equipment alone. At the same time as he was inventing the latter, he was also testing out his expertise in the field of architecture, making designs for sacred buildings and setting about impressing the Milan Cathedral Workshop with his archi-

*View and plan of a central space church,*
c. 1488
Pen and ink over black chalk, 240 x 190 mm
Paris, Bibliothèque de l'Institut de France

PAGE 32 (ABOVE):
*Drawing of a Flying Machine,* c. 1485
Pen and ink, 230 x 160 mm
Paris, Bibliothèque de l'Institut de France

PAGE 32 (BELOW):
*Battle Cart with Mobile Scythes,* c. 1485
Pen and ink with wash, 200 x 280 mm
Turin, Biblioteca Reale

Leonardo made this illustration of a battle cart from a contemporary treatise on warfare, but warned that this device could be equally dangerous for both sides.

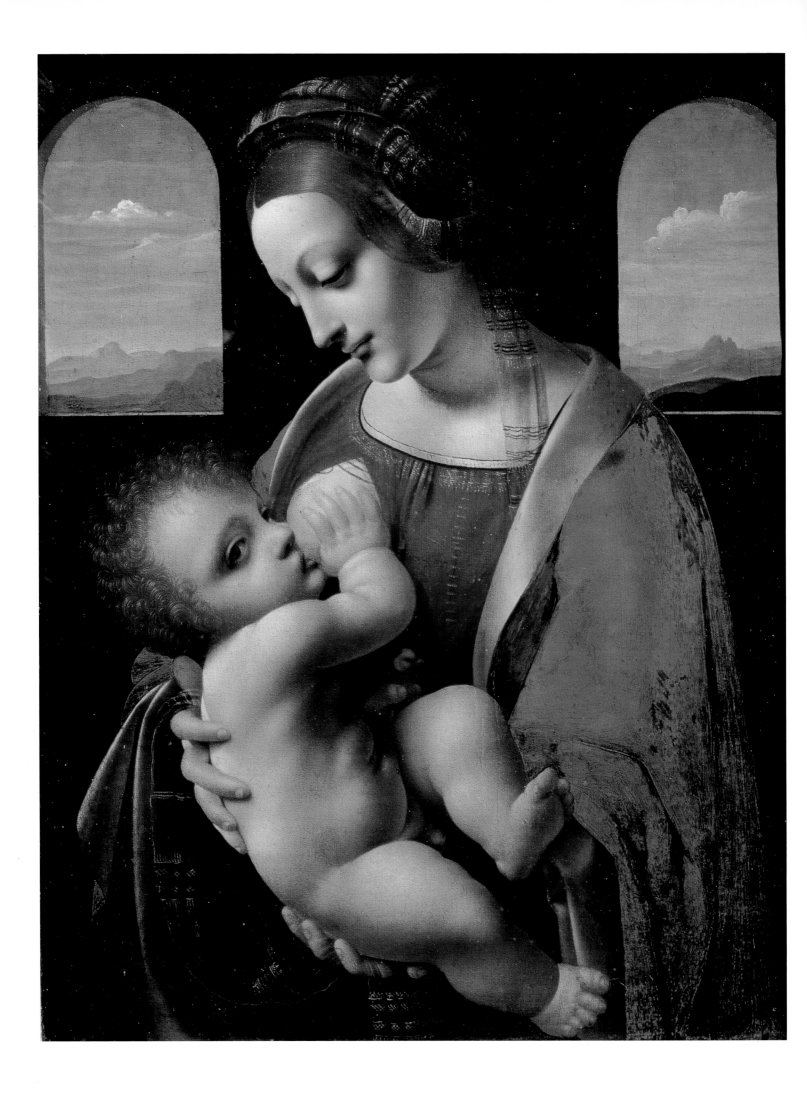

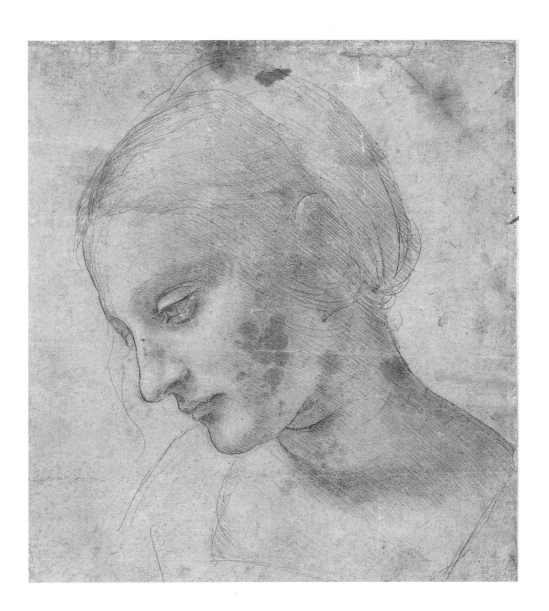

*Study for the Head of a Woman,* c. 1490
Silverpoint on greenish prepared paper,
180 x 168 mm
Paris, Musée du Louvre

PAGE 34:
*Madonna Litta,* c. 1490
Oil on canvas (transferred from panel),
42 x 33 cm
St. Petersburg, Hermitage

The attribution of this Madonna to Leonardo
remains controversial, even although a
preparatory study held in the Louvre indicates
that he played a decisive part in its composi-
tion at least.

tectural designs. There are records of a number of small payments to the artist for
work carried out in this connection. More important than this are Leonardo's
numerous sketches for central space buildings – even if it seems that none of the
plans had direct results – for these reflect the architectural debate during the late
15th century on the matter of sacred buildings with a central space design. It was
only towards the end of this decade that Leonardo seems to have turned back more
productively to the visual arts. It is feasible that this was the time when he painted
the *Madonna Litta*, a small-format representation of the Virgin Mary and Child,
although the attribution of this work to Leonardo remains as contentious as ever.
The overall harshness of the outlines of both figures plus the comparatively
unspectacular background in terms of atmosphere lead one to suspect the hand of
a pupil here who had been given the work to execute or to finish by his master.
At the same time, an authenticated preparatory study by Leonardo for the *Madonna
Litta* does show that he was directly involved at least in the composition of the
picture.

# The Artist as Natural Scientist

In the mid to late 1480s, when Leonardo was attempting to establish himself as a court artist, he seems to have started on his huge range of drawings that touch on almost all areas of science, and which to this day constitute a significant part of his reputation. Besides technical, artistic and 'scientific' drawings there are also various studies from this period which can really only be described as fantastical. This applies as much to some of the military equipment already mentioned here as to his numerous designs for flying machines (illus. p. 32). These drawings are intriguing and fascinating in themselves, and not simply with regard to the potential airworthiness of these machines. No doubt the artist was fully aware of the problems that would come with any such undertaking. Nevertheless he returned again and again to studies of the flight of birds, the aerodynamics of flying and the construction of wings. Curiosity and fantasy clearly spurred him on to make studies and designs which went far beyond the technical capabilities of his own times. One might even describe such determination as a triumph of 'scientific' curiosity (if we may already use the term 'science' here) over any prospect of these designs being realised in practice.

During the late 1480s, when he was working on the equestrian monument to Francesco Sforza (see below), Leonardo also embarked for the first time on extensive groups of studies on the proportions of the human body, on anatomy and physiology. Thus in April 1489 he began a book with the title 'On the Human Figure'. In connection with this book project – which was of course never finished – he made systematic studies of two young men. After what must have been months of taking measurements, as he was doing at almost exactly the same time with horses belonging to his patron Ludovico il Moro, he arrived at a systematic overview of human proportions, at which point he then started to look at the proportions of sitting and kneeling figures. He then compared the results of his anthropometric studies – taking human measurments – with the only surviving theory of proportions from Antiquity, namely the *Vitruvian Man*. Vitruvius, a moderately successful architect and engineer during the days of the Roman Empire had written a treatise on architecture which included in its third book a description of the complete measurements of the human body. These led him to conclude that a man with legs and arms outstretched would fit into the square and the circle, perfect geometric figures. And, still according to Vitruvius, if the figure were to be shown within a circle and a square ("homo ad circulum" and "homo ad quadratum") then the centre of the human body would coincide with the navel. Vitruvius's measurement were frequently illustrated during the Renaissance and later – with widely differing results. The best known of these drawings is

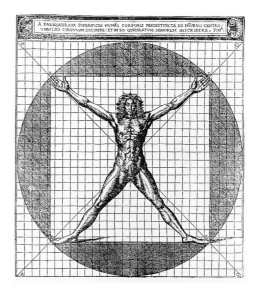

***Vitruvian Man,*** from Cesare Cesariano's commentary on Vitruvius of 1521

Cesariano gave his figure very large hands and feet in order to fit it into a square contained in a circle.

PAGE 36:
***The Proportions of the Human Figure,*** after Vitruvius (*Vitruvian Man*), 1490. Pen, ink and watercolour over metalpoint, 344 x 245 mm Venice, Gallerie dell'Accademia

With his famous *Vitruvian Man* – probably the best known of all his drawings – Leonardo re-interpreted the ancient teachings of Vitruvius on the proportions of the human body.

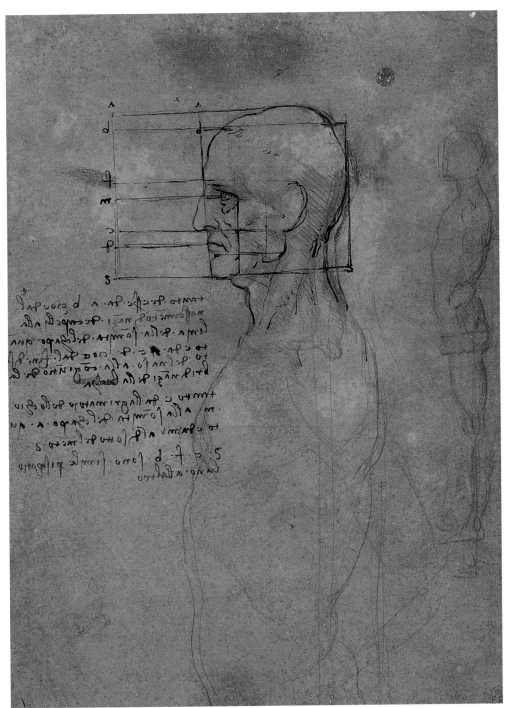

*Study for Man's Head in Profile,* c. 1490
Silverpoint, worked over in ink, on blue
prepared paper, 213 x 153 mm
Windsor, Windsor Castle

*Two Views of the Skull,* 1489
Pen and ink over black chalk, 188 x 134 mm
Windsor, Windsor Castle

Leonardo added the following commentary to
this drawing: "Where the line a-m is inter-
sected by the line c-b, there will be the
confluence of all the senses, and where the
line r-n is intersected by the line h-f, there the
fulcrum of the cranium is located at one third
up from the base line of the head."

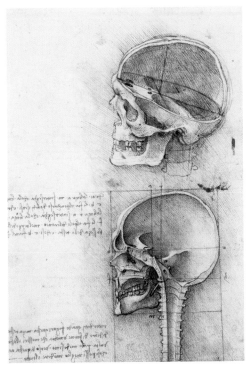

Leonardo's; rather more notorious is the woodcut by the Milanese surveyor Cesare
Cesariano showing a figure who not only has a remarkable erection, but also has
enormous hands and strikingly long feet (illus. p. 37). Like many other authors,
Cesariano had understood the geometry of Vitruvius's description as a medieval
civil engineer would, and had related the two figures, the circle and the square,
directly to each other: that is to say, the circle fits perfectly round the square, and,
in order to fit into this geometric construction, the figure needed to stretch out
considerably – hence the huge hands and elongated feet. Leonardo, on the other
hand, did not concern himself with the geometric relationship between the circle
and the square, and the two geometric figures in his drawing are not constrained
by their relationship to each other. On the basis of his own findings he corrected
inconsistencies in Vitruvius's measurements, guided throughout by his own empir-
ical knowledge of human measurements. Thus the hands and feet in his version
revert to a suitable size. Now only the centre of the circle round the "homo ad
circulum" coincides with the navel, the centre of the square enclosing "homo ad

PAGE 38:
*Head Measured, and Horsemen,*
c. 1490 and 1504
Pen and ink, and red chalk, 279 x 223 mm
Venice, Gallerie dell'Accademia

This drawing of c. 1490, used again in 1504
for studies of two horsemen, shows
Leonardo's use of different styles for
different subjects. There is also a noticeable
development in Leonardo's technique: the
later red chalk drawings are much livelier.

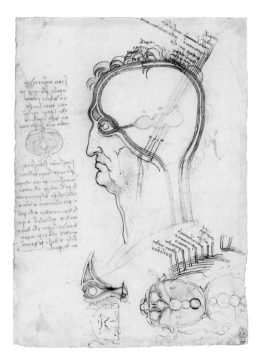

*Vertical and Horizontal Sections of the Human Head,* 1489
Red chalk, worked over in pen, 206 x 148 mm
Windsor, Windsor Castle

Here Leonardo illustrates the traditional medieval theory of the brain and its three ventricles, showing their functions.

PAGE 41:
*Coition of Hemisected Man and Woman,*
c. 1492
Pen and ink, 273 x 202 mm
Windsor, Windsor Castle

In this drawing Leonardo illustrates Classical and medieval notions of the origins of male sperm (partly from the brain) and the mother's milk (from the womb). The penis shows two channels: one for the sperm and one for a spiritual substance from the brain.

quadratum" is located somewhat lower. Through the precision of his own measurments Leonardo had managed to overcome the canon of Antiquity as well as creating an image that we accept as a true representation of Vitruvius's findings.

Detailed knowledge of human proportions had already become a matter of course for many artists by the mid-15th century, although none had devoted such detailed attention to it as Leonardo. Having by now established himself in Milan as an artist, he then went much further than other artists in his anatomical studies, which he also started in the late 1480s. At this time he certainly studied the dimensions of the human skull as well as the different "ventricles" of the brain, although he allowed himself to be largely misled by certain false notions handed down from Antiquity and the Middle Ages, and by others which were simply the common currency of the time. In keeping with these notions, Leonardo located the centre of human common sense (sensus communis) – as the physiological switchboard of human perception – in a precisely definable spot, which he marked at exactly the point where two lines intersected (illus. p. 39). In another drawing, showing vertical and horizontal sections of the human skull, Leonardo demonstrates the notion commonly held in the Middle Ages, that the human brain consisted of three sections, which he portrays as three chambers the size of nutshells. The first of these three chambers, which are arranged one behind the other, receives sense impressions, the second processes them and the third stores them. An even more striking anatomical misapprehension which he took over from Antiquity and the Middle Ages is evident in his so-called coitus drawing. In an illustration of sexual intercourse Leonardo portrays current notions of the links between the internal organs: a tube-like channel leads from the woman's breasts to her womb, while the erect male organ is directly linked both to the testicles and the spinal cord and thus to the brain. In accordance with this, the sketches beneath this illustration showing a cross section and a longitudinal section of the penis show two channels, the lower for the sperm from the testicles and the upper for the mental powers transported from the brain along the spinal cord. Later on, having made extensive studies of dissected corpses, Leonardo increasingly questioned these antiquated notions of the human anatomy and how it functions.

Leonardo's conviction that the inner organs of the human being are closely interconnected reflects his concept of the deep complexity of human nature. The two channels in the penis, as it were, illustrate the view that procreation is not just a matter of sperm but needs a spiritual substance, too. This substance, which was after all coming from the very seat of the soul, provided the higher spiritual dimension, while the sperm from the testicles, with its own specific make-up, was more about lower impulses although these would include courage in battle. Leonardo also expressed similar notions regarding the effect and the function of substances associated with different parts of the body: for instance tears came directly from the heart, the seat of all feeling. Views of this sort, of course, meant that particular emotional meanings became attached to different organs. Leonardo also regarded the human physiognomy as equally immediate, and endeavoured to illustrate the immediacy of facial expression in countless character heads and caricatures. These drawings – often grotesque rather than realistic, and almost always showing older rather than younger faces – above all express the idea that the human face is a direct reflection of an individual's underlying character and momentary sensations. In keeping with this view, therefore, a man whose face resembles that of a lion in all probability shares that same animal's main charac-

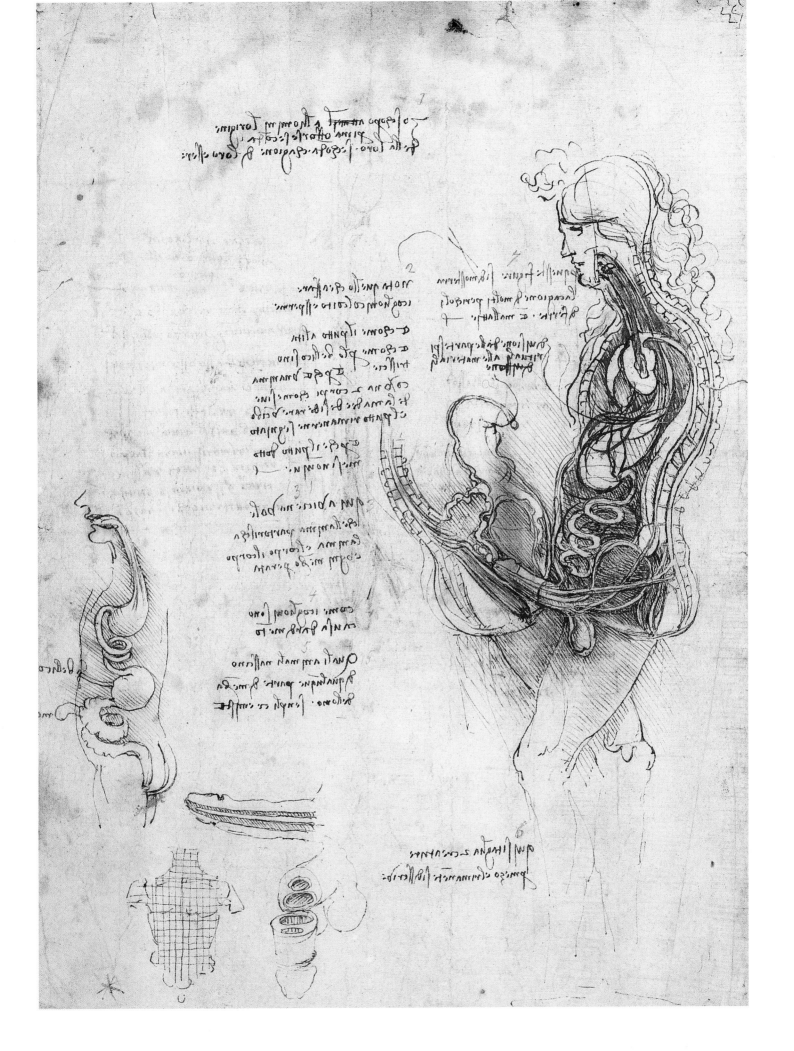

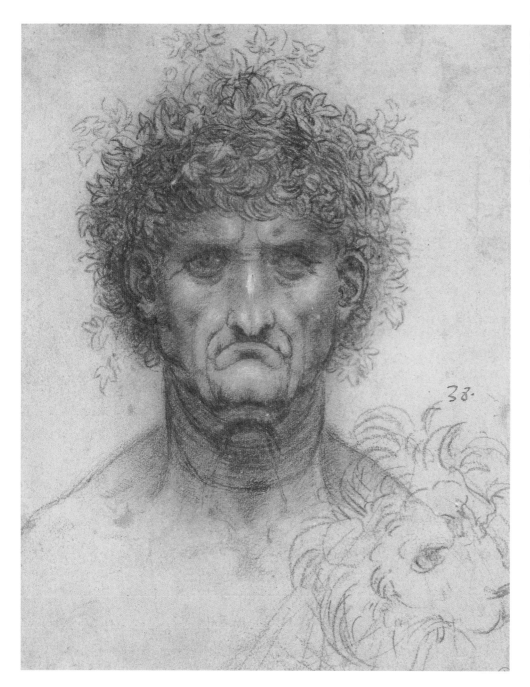

*Head of a Man and of a Lion (Bacchus?),*
c. 1503–1505
Red chalk heightened with white on pink
tinted paper, 183 x 136 mm
Windsor, Windsor Castle

A wreath of ivy and the head of a lion
together were attributes of Bacchus, but this
drawing also illustrates the common view that
a person's physiognomy says something
about their character.

teristics. In one of his studies in particular Leonardo sticks firmly to this physiognomic platitude: a man with lionine features even has a lion-skin flung across his shoulders, with the lion's head clearly visible (illus. p. 43). The same idea is also behind Leonardo's famous drawing with five grotesque heads: an old man shown in profile is surrounded by four more faces, whose strongly expressive features reveal very different, largely negative characteristics. They seem to be mocking the man in the centre, jeering and grimly staring at him, while the man in profile proudly does not deign to notice their scorn – his own features are not distorted like those of his would-be tormentors, but nevertheless deeply lined and marked by fate.

PAGE 43:
*Five Grotesque Heads,* c. 1490
Pen and ink, 261 x 206 mm
Windsor, Windsor Castle

The wreath of oak leaves on the head of the
old man in profile in the centre indicates that
this figure is to be viewed positively. He is
surrounded by four less appealing contemporaries, whose physiognomies express
different, rather more negative states of mind.

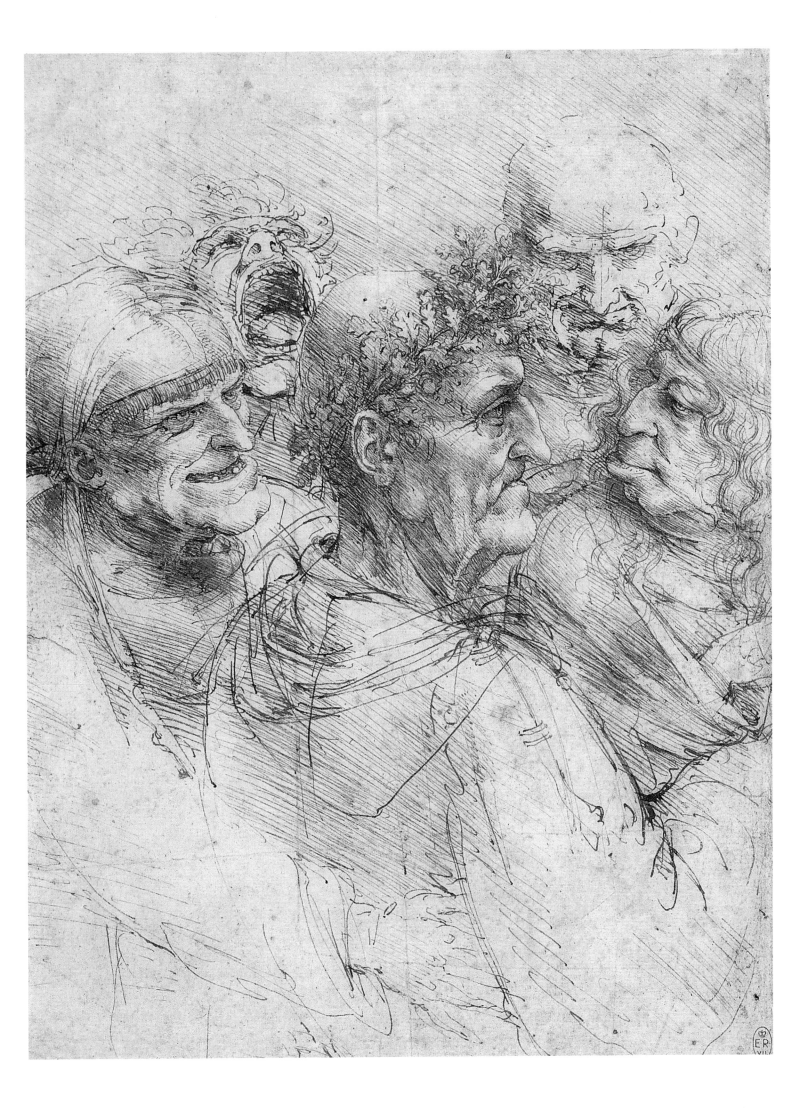

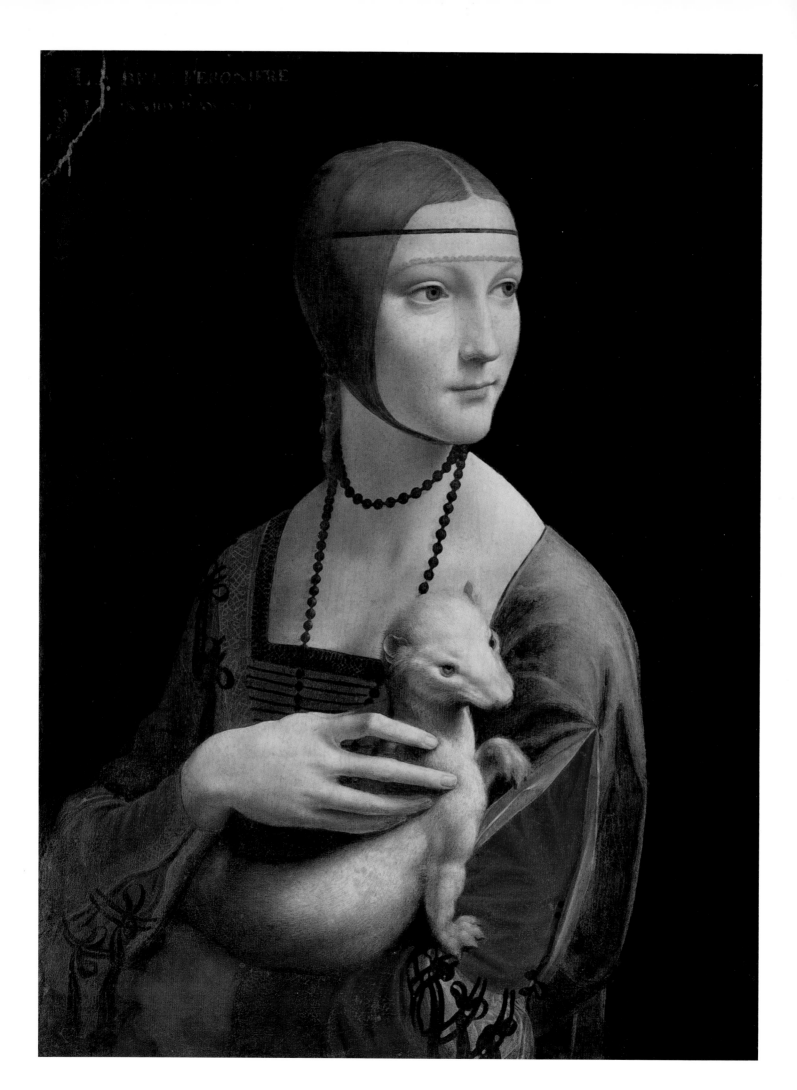

# Leonardo: Court Artist in Milan

Between 1487 and 1490, in other words at much the same time as he was embarking on his anatomical studies, Leonardo took up a position at the court of Ludovico il Moro in Milan. Here he organised festivities and worked for several years on the equestrian statue of Francesco Sforza (which was never realised), made a name for himself as a portraitist and painted his famous mural of the 'Last Supper'. Amongst his earliest completed works as court artist are a number of portraits, including the captivating *Lady with an Ermine (Cecilia Gallerani)* and the so-called *Belle Ferronière* (illus. p. 49), although there is not unanimous agreement that the latter should be attributed to Leonardo. Similar uncertainty surrounds another portrait made during Leonardo's time in Milan: *Portrait of a young man*, taken to be a musician because he is holding a sheet of music in his right hand. Compared to the portraits of the Belle Ferronière and Cecilia Gallerani, this image of a young man looking out of the picture towards the right seems rather wooden, which is no doubt partly due to the fact that the musician's upper body is angled in the same direction as his gaze. In the portraits of the two women, the respective movements show opposing orientation: while the upper body is turned to the left, the head faces to the right. Both of these portraits are in keeping with a dynamic style of portraiture which Leonardo was already working towards in the *Portrait of Ginevra de'Benci* (see pp. 19ff.) and which he made explicit reference to in his *Treatise on Painting* (fol. 122). His ideas on the portrayal of a figure in motion are seen most distinctly in the *Lady with an Ermine (Cecilia Gallerani)*, for in this the movements in opposing direction of head and body are particularly clear. Moreover the ermine repeats the movement of the young woman, whose elegantly curved hand in turn corresponds with the movement of the animal. On the one hand the ermine is an allusion to the sitter's surname, for the sound of the name 'Galleriani' is reminiscent of the Greek word for ermine, 'galée'. On the other hand, this small creature was taken as a symbol of purity and modesty, for according to legend it abhorred dirt and only ate once a day (Ms. H, fol. 12). From the late 1480s onwards the ermine could also be read as an allusion to Ludovico Sforza, who used it as one of his emblems. Thus Ludovico, in the form of a symbolical animal, is mildly teased and gently caressed in the sitter's arms. The particularly finely balanced situation and the comparatively complex symbolism of this portrait derive from the circumstances of the young lady, for in 1489, Cecilia, born in either 1473 or 1474, was Ludovico Sforza's favourite mistress. There is documentary evidence of this portrait having been in her possession, perhaps in memory of the premarital and extramarital pleasures she and Ludovico shared. In 1491, that is to say not long after the portrait was painted, Ludovico married Beatrice d'Este.

***Allegory with Ermine,*** c. 1490
Pen and ink, diameter 91 mm
Cambridge, Fitzwilliam Museum

In this allegory Leonardo depicts the traditional belief that an ermine would rather be killed than sully its white fur in dirty water as it flees. Thus the ermine was regarded as a symbol of purity.

PAGE 44:
***Portrait of Cecilia Gallerani***
***(Lady with an Ermine),*** c. 1490
Oil on wood, 54.8 x 40.3 cm
Cracow, Czartorychi Muzeum

This portrait of Ludovico Sforza's most important mistress has a dynamism that goes far beyond the conventions applying to portraiture in Milan at the time. The ermine was regarded as a symbol of purity and virtue, but was also an allusion to Ludovico Sforza, Cecilia's lover.

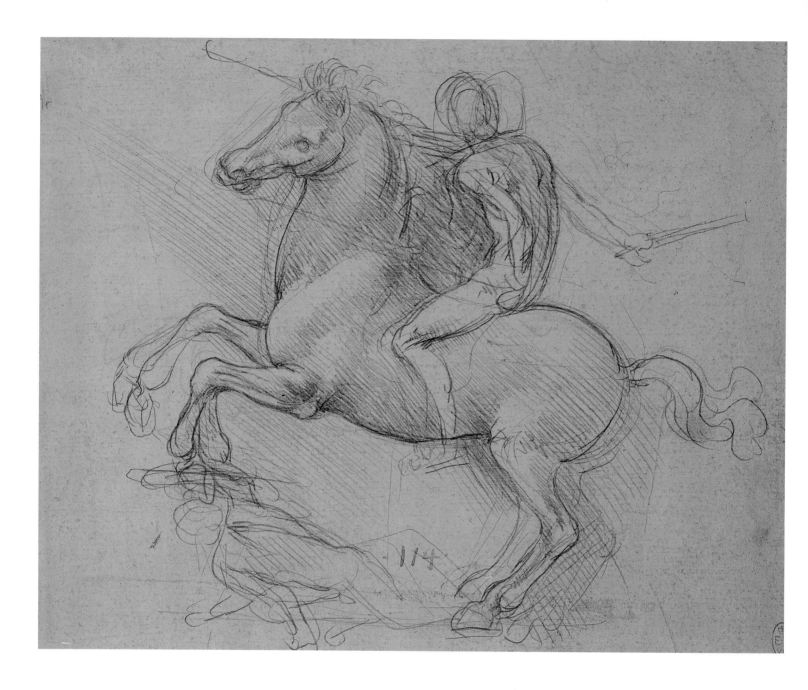

The elegance of the courtly portraits might easily lead one to forget that at approximately the same time, Leonardo was responsible for a much more important and also much more difficult project, namely the monument to Francesco Sforza – the largest project of its kind in the modern age. It was Ludovico's intention to commemorate his father's military successes with an out-sized, bronze monument, which was of course also calculated to cast his own achievements in an equally impressive light. Plans had first been drawn up for an equestrian monument in the early 1470s, but their execution had been repeatedly postponed, until Leonardo – probably around 1489, or perhaps a little earlier – began on the work for the statue. In late 1492 Leonardo made a huge clay model of the horse, over seven metres (!) in height, which already featured the following year at the festivities to mark the marriage of Bianca Maria Sforza, Ludovico's niece, to the Emperor Maximilian. However, this ambitious project was not to progress far beyond the model, for in 1494 the bronze intended for the casting was designated for a different use and turned into cannons.

For some years the clay model of the Sforza monument in Milan aroused the curiosity and admiration of guests and others passing through, but after the arrival

*Study for the Sforza Monument,*
c. 1488–1489
Silverpoint on blue prepared paper,
148 x 185 mm
Windsor, Windsor Castle

This immensely dynamic, early sketch for an equestrian monument to Francesco Sforza shows Leonardo's original plans for a rearing horse.

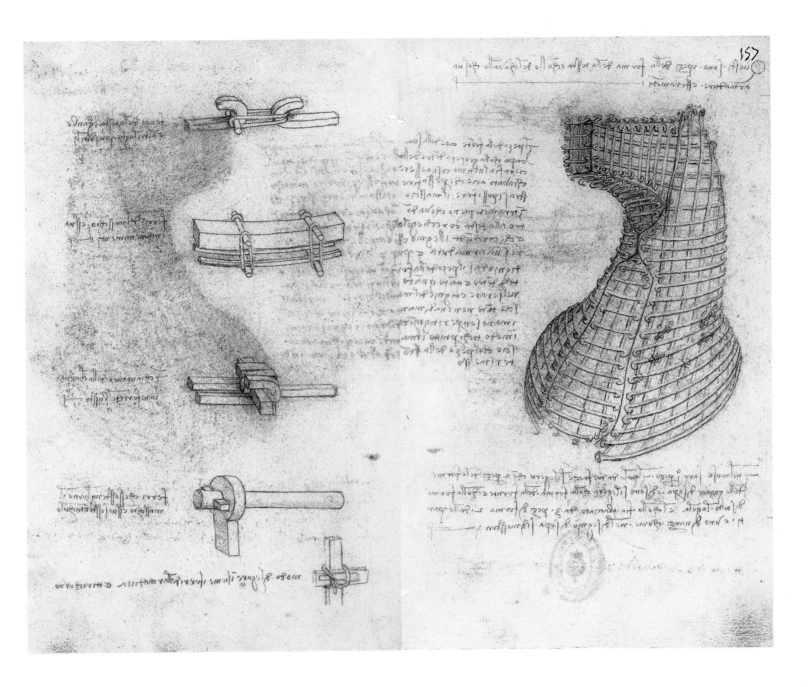

***Device for Securing the Piece-Mould of a Horse's Head for Casting,*** c. 1491–1493
Red chalk, 220 x 300 mm
Madrid, Biblioteca Nacional

This is a strangely surrealistic double page from the so-called Codex Madrid where Leonardo illustrates how the mould for the horse's head for the Sforza Monument was to be held in place.

of the French troops in 1499 it fell into the hands of mercenaries who had little interest in art. According to contemporary accounts the archers used it for target practice, and thus it was largely ruined. However, numerous sketches and preparatory studies have survived which convey a lively impression of the different stages and the technical challenges of the project. Thus, besides the somewhat surrealistic depiction of the armoured outer covering for the casting, there are also numerous studies for the final appearance, the movements and the proportions of the horse. The most impressive of these studies shows a rider on a horse rearing up plus an opponent who has clearly fallen to the ground and is now attempting to protect himself from further attack with his shield raised in his right hand. Since the construction of a horse rearing up on two legs would, however, have caused considerable complications regarding the stability of the statue, in the next planning stage, Leonardo decided to use the less dramatic option of a horse striding forwards. The motif of the rearing horse remained an artistic ideal, which Leonardo took up again later on, but which was not seen in sculptural form until the 17th century.

Leonardo's extensive, extravagant work on the equestrian statue served as his own best recommendation for the position of court artist to Ludovico Sforza in

47

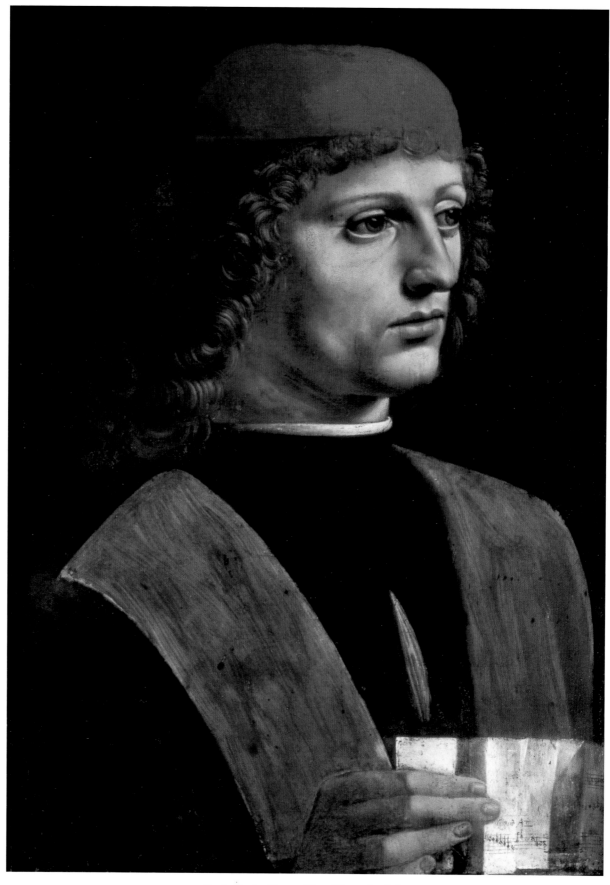

***Portrait of a Young Man (Portrait of the
Musician Franchino Gaffurio?),*** c. 1490
Oil on wood, 44.7 x 32 cm
Milan, Pinacoteca Ambrosiana

Because of the young man's somewhat rigid
pose and the harshness of the shadows, doubts
have at times been expressed regarding the
attribution of this painting to Leonardo.

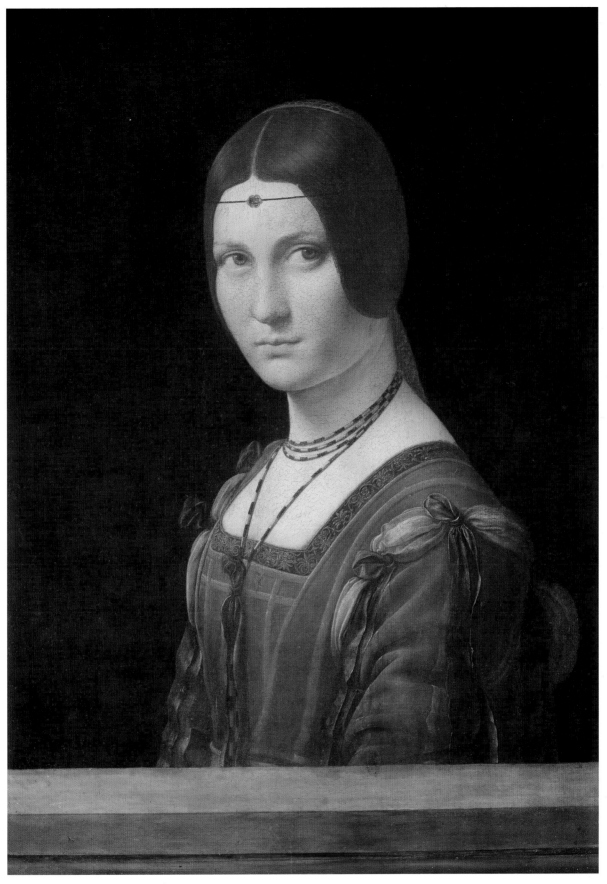

***Portrait of an Unknown Woman
(La Belle Ferronière),*** c. 1490
Oil on wood, 63 x 45 cm
Paris, Musée du Louvre

The attribution of this portrait to Leonardo is
not entirely certain, but the technique and the
shading used here would suggest that it is
indeed his work.

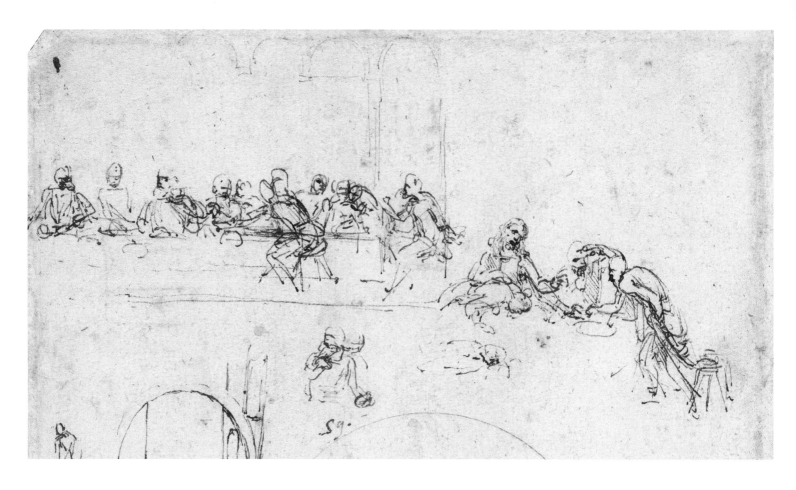

***First Sketch for the Last Supper,*** c. 1495
Pen and ink, 260 x 210 mm
Windsor, Windsor Castle

In this first sketch for the *Last Supper* Christ's
disciples are not yet arranged in groups, but
the vitality of the scene is already abundantly
evident.

Milan. In this capacity, besides turning his attention even to the heating of the
ducal palace, he designed decorations for courtly festivities and produced paint-
ings. As well as the portraits already mentioned above, his paintings also included
the *Last Supper* in the refectory of the Monastery S. Maria delle Grazie (illus. pp.
52–53) and the so-called 'Sala delle Asse' (illus. p. 59) in the Castello Sforzesco
in Milan. Particularly the *Last Supper* and, later on, the *Mona Lisa* led to Leonar-
do's fame as a painter. However, the wall-painting of the *Last Supper* – painted
between 1495 and 1497 in not very durable tempera – already began to show first
signs of decay in the 16th century, which subsequent generations have tried to halt
ever since with repeated attempts at restoration. Even so, the condition of the
painting, which was already described as damaged in the 16th century, has never
in the slightest detracted from its immense impact. Known the world over in
countless copies, reworkings and illustrations, this is the most famous version of
this theme. Like the Florentine artists before him, Leonardo portrayed the 'Last
Supper' in a stage-like setting, constructed according to the rules of central per-
spective. The lines of perspective meet in Christ's right eye, which in itself empha-
sises his central position both in the actual situation, and in its depiction. For his
portrayal, Leonardo concentrated on the moment when Jesus sits down with his
disciples and declares: "Verily I say unto you, that one of you shall betray me"
(Matthew 26.21). In widely differing gestures and reactions almost all the disciples
express their astonishment and horror at this news of imminent betrayal: at the left
end of the table Bartholomew rises up from his chair in agitation, next to him
James the Less and Andrew raise their hands in surprise. Peter is also getting up
from his chair and looks angrily towards the centre of the picture. In front of him
is the traitor Judas, leaning back in shock, but with his right hand fingering the
pouch with the money he has been paid to betray the Lord. For the first time in
the history of post-medieval depictions of the Last Supper, Judas is not shown
sitting in front of the table, but is now behind it. Thus he is placed immediately

**Study for the Last Supper (St. James the
Greater) and Architectural Sketches,** c. 1495
Red chalk, pen and ink, 252 x 172 mm
Windsor, Windsor Castle

As in his other drawings for the *Last Supper*
here, too, Leonardo is studying the expressive
potential of the human face. In the painting
James has a beard and longer hair; in the
drawing Leonardo was still concentrating on
the physiognomic expression of the face.

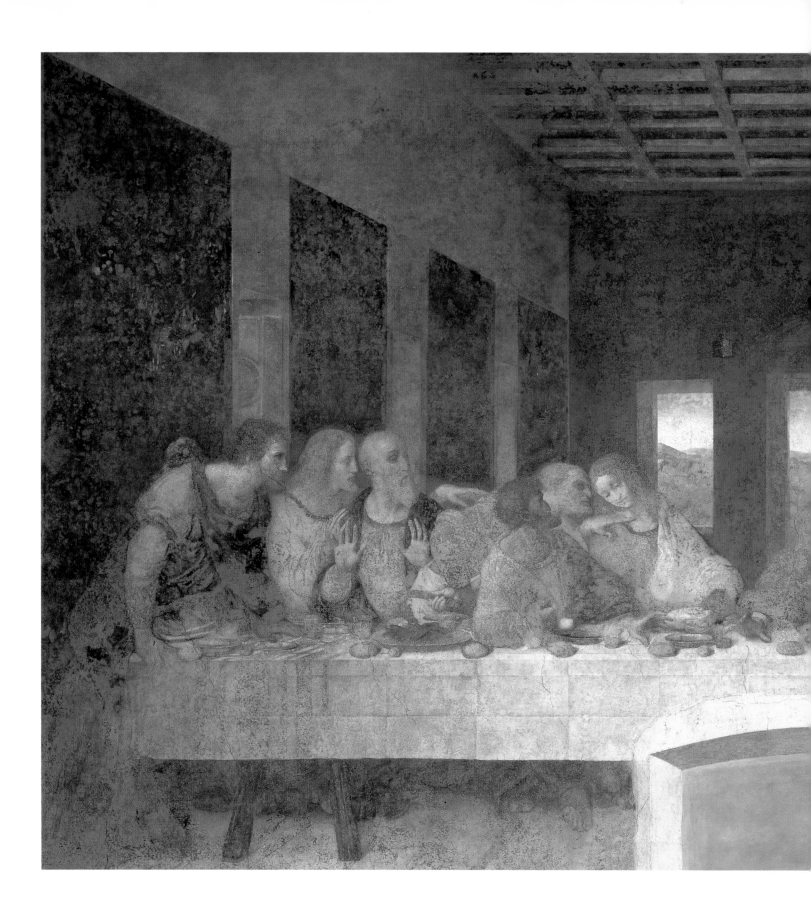

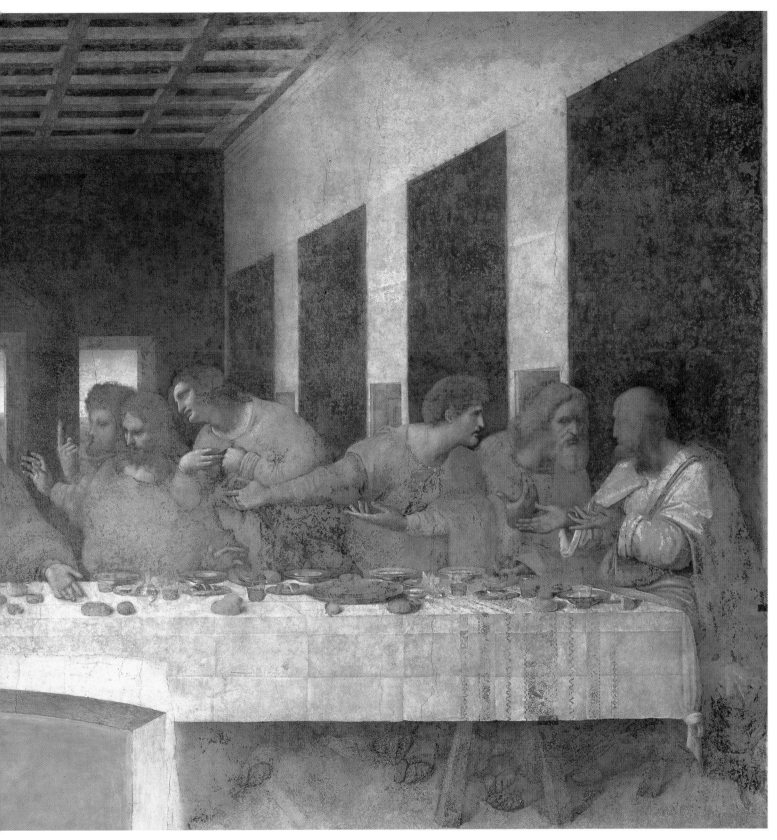

***The Last Supper,*** c. 1495–1498
Oil and tempera on plaster, 460 x 880 cm
Milan, Santa Maria delle Grazie, Refectory

By now seriously damaged, this work is
distinguished above all by the contrasting
groups of figures as well as by the finely
calculated portrayal of gesture and facial
expression.

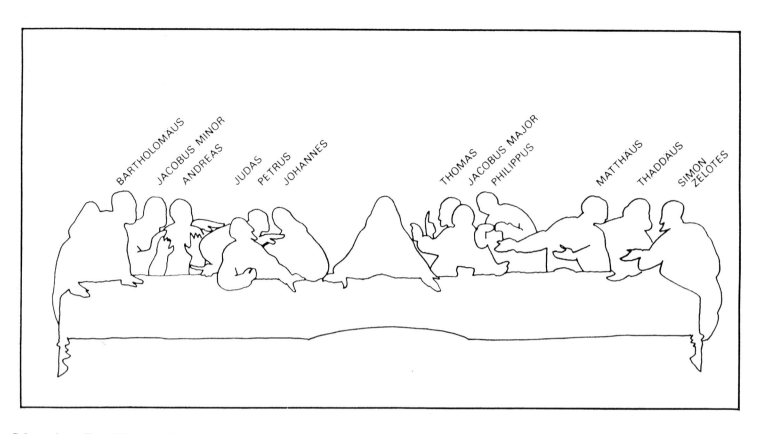

BARTHOLOMÄUS
JACOBUS MINOR
ANDREAS
JUDAS
PETRUS
JOHANNES
THOMAS
JACOBUS MAJOR
PHILIPPUS
MATTHÄUS
THADDÄUS
SIMON ZELOTES

**Schematic outline of the Last Supper with the names of the disciples**

The identification of the disciples is based on an old copy of the *Last Supper* in Ponte Capriasca (Lugano) with the relevant names. Leonardo himself avoided inscriptions of this kind since, like haloes, they detract from the pictorial effect.

Unknown artist of the 16th century
**Copy after Leonardo's Last Supper**
Oil on canvas, 4.18 x 7.94 m
Tongerlo, Da Vinci Museum

This copy, almost as large as the original, displays a wealth of detail which is no longer visible in Leonardo's wall-painting due to the extensive damage it has suffered.

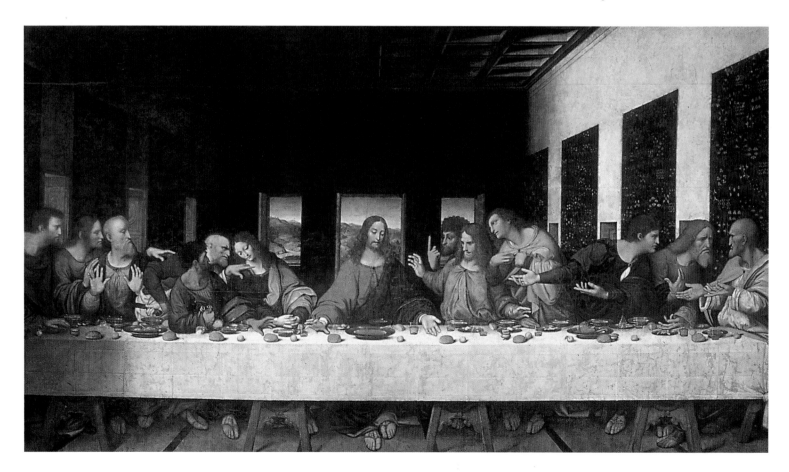

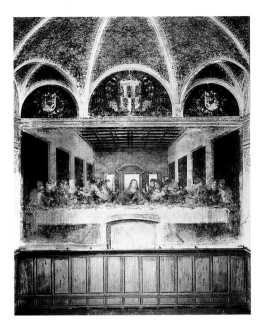

*Overall view of the Last Supper with the lunettes,* c. 1495–1497
Milan, Santa Maria delle Grazie, Refectory

In the lunettes above the Last Supper Leonardo put the coats of arms of the Sforza family. The groups of disciples in Leonardo's painting reflect the rhythmic divisions in the wall created by the three lunettes.

*The Last Supper* (detail)

In recent efforts to restore the *Last Supper*, over-paintings from past centuries have been removed. Now numerous details are almost as clearly visible as the irreparable damage to the painting which results, in part, from Leonardo's experimentation with paint techniques.

next to John, whose reaction is more muted (he does not yet know the identity of the traitor) as he looks to the front, with folded hands, almost contemplatively. Comparatively motionless, positioned in the centre of the composition and framed by the window behind him, sits Jesus himself. On his other side are two more groups of three disciples each: Thomas, James the Great and Philip in one; Matthew, Thaddeus and Simon in the other.

Unlike paintings of the Last Supper by his immediate contemporaries, Leonardo imbues the scene with life by dividing the twelve apostles into four different groups, and by endowing his figures with precisely calculated, individual gestures and expressions. The drawings, sketches and preparatory work immediately preceding the painting itself, as well as some eye-witness reports, all confirm the fact that the artist went to incomparable lengths to achieve a quite particular variety of gesture and facial expression. To this end he searched Milan and its surroundings for strongly expressive facial types that he could use for the individual disciples; he even sought out suitable models for their hands. These meticulous preparations may also be seen in the intensive physiognomic studies for the faces of James the Great, Judas and Philip. Similarly, in the overall composition of the work, Leonardo was treading new ground in artistic terms by dividing the twelve disciples into groups of three, and thus yet further heightening the tension in the already emotional atmosphere of the scene. These groups are not only an element in Leonardo's efforts to dramatise the scene, but are also connected to the location of this *Last Supper*. In the top section of the wall of the refectory with Leonardo's painting there are three lunettes, which in turn influence the rhythm of the groups of figures below: the disciples at the two outer ends of the table are beneath the two smaller arches, while the two inner groups and Christ himself are all beneath the central arch. The lunettes themselves display coats of arms surrounded by plants and heraldic ornament. In the centre is the coat of arms of the client, Ludovico Sforza combined with that of his wife Beatrice d'Este; on his right (the viewer's left) is the coat of arms of his first-born son Massimiliano and on his left that of his second-born son Francesco. Bearing in mind that Ludovico had had the adjoining Church of S. Maria delle Grazie altered specifically as a last resting place for his family, then Leonardo's *Last Supper* is not merely an outstanding example of artistic innovation and creativity, but also a dynastic statement by his client. The same also applies to the last surviving commission Leonardo carried out for Ludovico Sforza, the so-called 'Sala delle Asse' which was created in the Castello Sforzesco between 1496 and 1498. Here Leonardo decorated a whole room with the artfully intertwined branches of several trees around a coat of arms in the highest point of the vault and four tablets with inscriptions. The area around the coat of arms and the inscriptions name the most important political and private events in Ludovico's life: his marriage to Beatrice d'Este, the wedding of his niece Bianca Maria and the Emperor Maximilian, his advancement to become the Duke of Milan and the victory over the French in the Battle of Fornovo. But Duke Ludovico was not allowed long to savour the political triumph which Leonardo had so subtly reflected in the Sala delle Asse: by 1499 the political situation had already turned upside-down. French troops poured into Northern Italy once again and in October brought Ludovico's rule to an end. Leonardo remained in Milan for a few months, but in December 1499 set off for Mantua and Venice, no doubt hoping to find new patrons there.

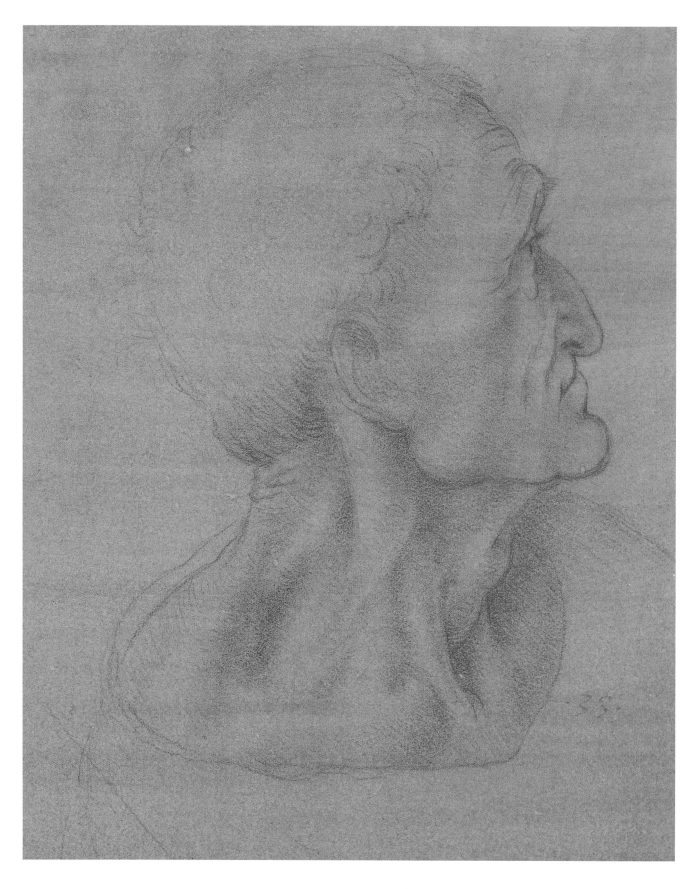

***Study for the Last Supper (Judas),*** c. 1495
Red chalk on reddish prepared paper,
180 x 150 mm. Windsor, Windsor Castle

We know from Leonardo's drawings and
contemporary reports that he carried out
intensive physiognomic studies to achieve
maximum variety in the heads of the disci-
ples. The drawing of Judas is the most
powerfully expressive of these studies.

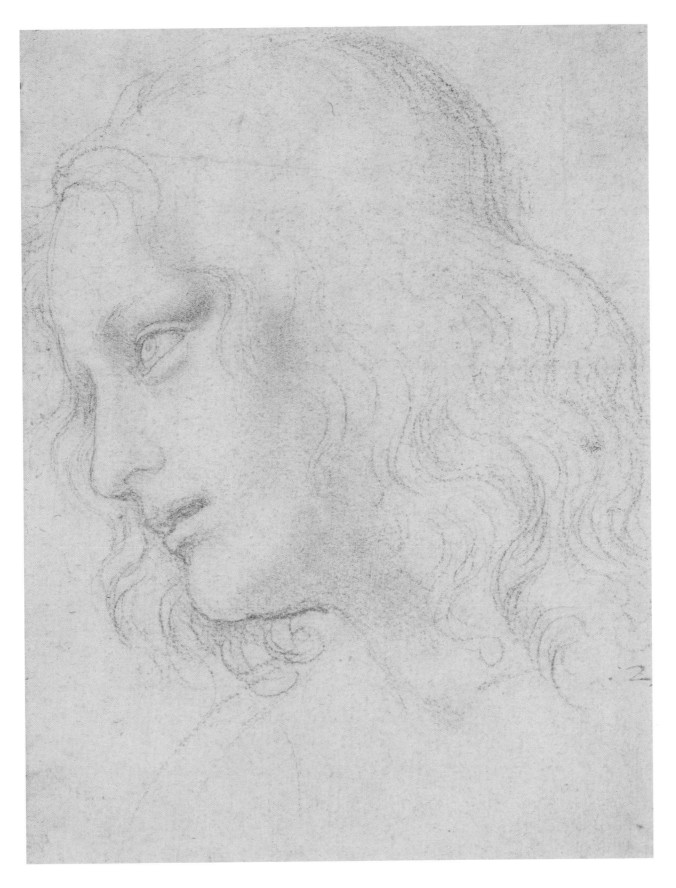

***Study for the Last Supper
(the Disciple Philip)***, c. 1495
Black chalk, 190 x 149 mm
Windsor, Windsor Castle

**Study for the Last Supper (Peter?),** c. 1495
Pen and ink over metalpoint on blue
prepared paper, 145 x 113 mm
Vienna, Graphische Sammlung Albertina

This study is presumably of Peter, but
was not used in the final version of the
*Last Supper*, because Leonardo decided on
a more dynamic variant.

***Sala delle Asse,*** c. 1496–1498
Tempera on plaster
Milan, Castello Sforzesco, Sala delle Asse

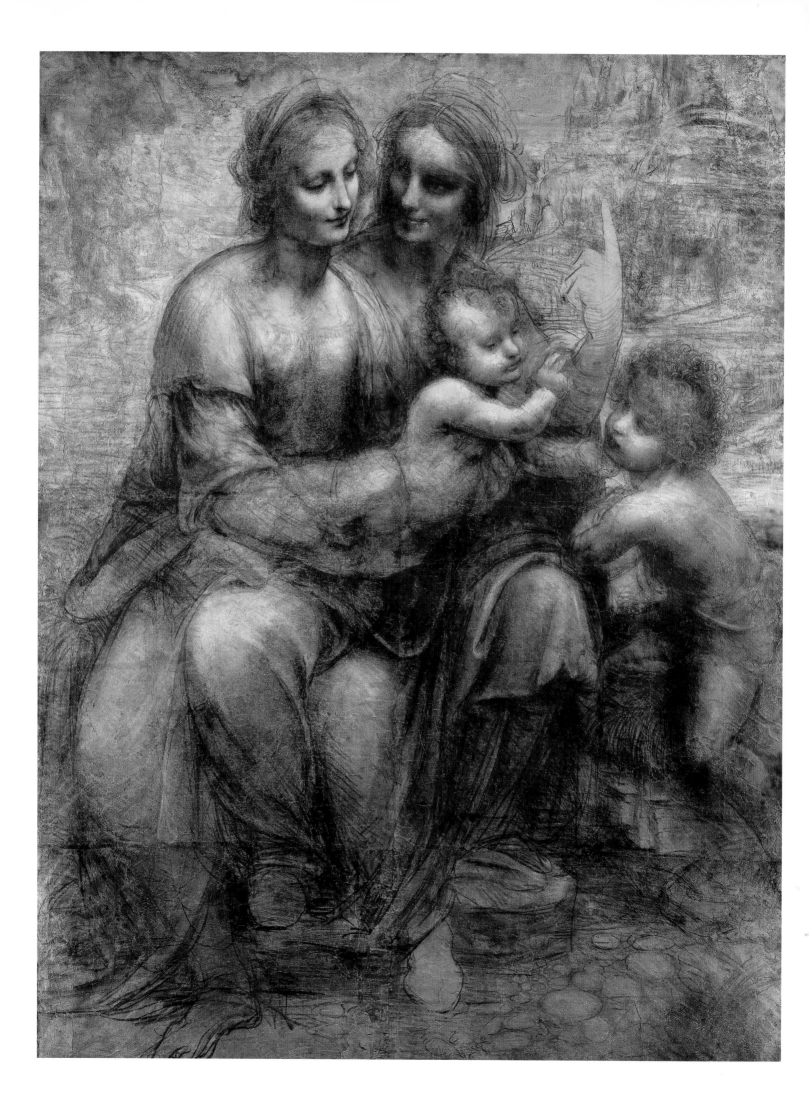

# Restless Interlude

With the fall of Ludovico Sforza Leonardo lost his most important and powerful patron so far. Yet he was, by now, famous beyond the boundaries of Italy and it seems that even before he left Milan he had already made contacts with the French court which were to be important to him in the future. Evidently the French King, Louis XII, had been very impressed by the *Last Supper* in S. Maria delle Grazie and also by the *Virgin of the Rocks*. In all probability this then moved him in October 1499 to commission a large-scale work from Leonardo showing Mary, St. Anne and Christ. This may well have been intended as a present for Anne de Bretagne, Louis XII's wife, but has only survived in its design stage. Now known as the 'Burlington House Cartoon', it shows the final composition of the picture. The figures are placed in front of a rocky landscape, Mary sits sideways on the lap of her mother Anne. The Child Jesus seems to be slipping out of her arms and, with his hand raised in a gesture of blessing, is turned towards the infant St John who is approaching from the right. In the upper region of the picture the outlines of the two women are already clearly defined; it is only their feet and Anne's left hand with its raised index finger that are unfinished. By contrast the faces stand out for their perfection, equal to any finished oil painting with their deep shadows and highlights.

The execution of this painting for Louis XII most likely fell victim to the restless existence Leonardo led after he left Milan in 1499. First he travelled to Mantua, where Isabella d'Este had acquired a reputation as a generous if somewhat capricious patron of the visual arts. It was probably here, in December 1499 or early the next year, that Leonardo made a cartoon of Isabella, in profile in the tradition of court portraiture in Mantua (illus. p. 63). This mode of representation not only ensured recognisability, but with its echoes of older styles conveyed the social norms prevailing at the time in court circles. It stands in marked contrast to a later character study of what must be a 'Gypsy Baron' (illus. p. 62), demonstrating a much less constrained concept of the human face: the expression in the physiognomy of the latter borders on the grotesque and carries no traces of norms or controls of any kind. The whole purpose of this drawing would appear to be expressivity, while the profile of Isabella d'Este is calculated to convey the impression of inner composure. Therefore, in this life-sized portrait, Leonardo avoided any disturbing elements, concentrating above all on the details of the face. Clear pin-pricks along the main lines in the cartoon (the same is found in the expressive drawing of the 'gypsy') indicate that the artist was already preparing to transfer the portrait to another surface. However, in all likelihood the cartoon design was never transferred to canvas since Leonardo left for Venice in March 1500 and in April moved on to Florence, where he soon found new clients and realms of activity.

*Sketch for the Virgin, Child, St. Anne and St. John,* c. 1508
Pen and ink, wash, heightened in places with white, over black chalk, 260 x 197 mm
London, British Museum

This sketch is typical of the spontaneity of Leonardo's method, which often involved drawing numerous variants of movements and pictorial ideas one on top of the other.

PAGE 60:
*Burlington House Cartoon (Mary, Christ, St. Anne and the Infant St. John),* 1499 (?)
Chalk on paper, 139.5 x 101 cm
London, National Gallery

The cartoon was presumably made as a design for a painting, which the King of France had commissioned from Leonardo as a present for his wife.

***Grotesque Portrait Study of Man,***
c. 1500–1505
Black chalk reworked in another hand,
pricked for transfer, 390 x 280 mm
Oxford, The Governing Body, Christ Church

The largest of Leonardo's so-called
'grotesque heads' is taken to be a portrait
of a gypsy. It is striking above all for its
greater realism and drama compared to the
Portrait of Isabella d'Este.

***Portrait of Isabella d'Este,*** c. 1499
Charcoal, black chalk and pastel on paper,
pricked for transfer, 63 x 46 cm
Paris, Musée du Louvre

This cartoon for a painting in the same size
(probably never realised) reveals Leonardo's portrait
technique. The most important contours are
perforated with fine pin-pricks, in order to transfer
the portrait accurately to another surface.

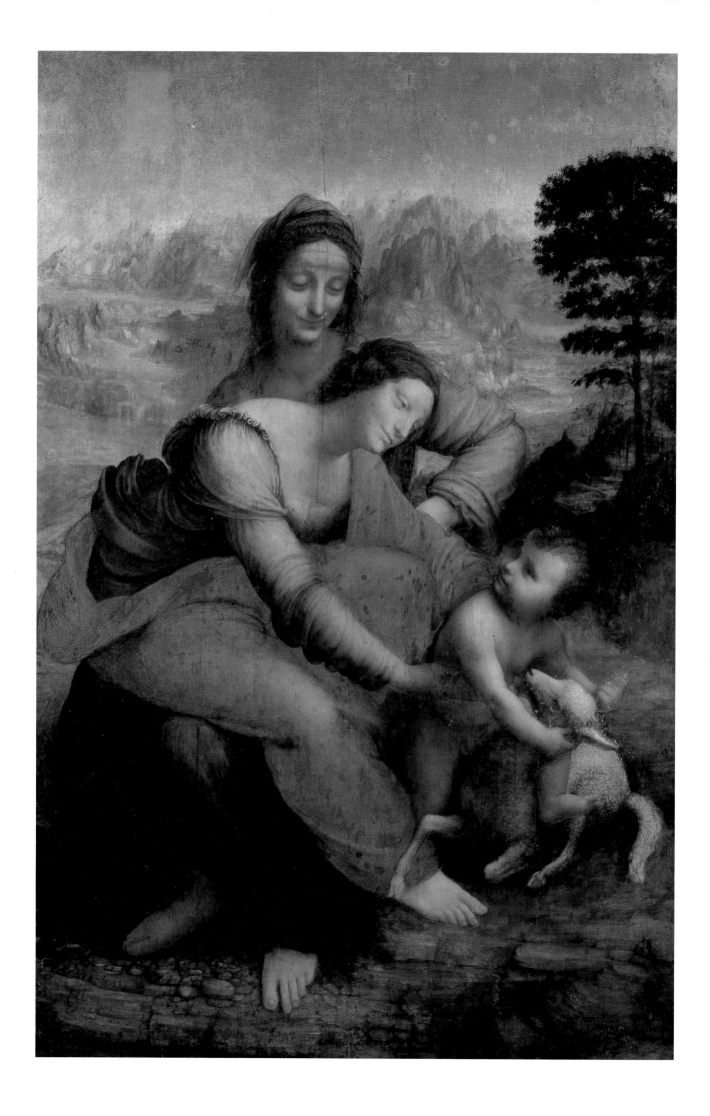

PAGE 64:
*Virgin and Child with St. Anne* c. 1502–1516
Oil on wood, 168 x 130 cm
Paris, Musée du Louvre

Towards the end of his life Leonardo returned to this painting which may originally have been intended as an altar painting for the Giacomini Tebalducci Chapel in the Florentine Church of SS. Annunziata.

According to Giorgio Vasari, following Leonardo's return to his native town, he accepted a commission for an altar painting for the Servite monks of SS. Annunziata. To this end, and working in the Servite monastery, he first of all made a cartoon of St. Anne, the Virgin and Child, and a lamb, which he evidently put on display for two days and which was much admired by the people of Florence. To this day it is not entirely clear which work Vasari is referring to, although at least in terms of its design, the painting of St. Anne now in the Louvre could well have been made in Florence in 1500–01. This is in keeping with a letter written on 3 April 1501 by the Carmelite monk Fra Pietro da Novellara in which he mentions Leonardo in Florence: "Leonardo's lifestyle is erratic and very fickle, and it would appear that he just lives from one day to the next. Since he has been in Florence he has only made one cartoon, with the Holy Child at about the age of one, almost escaping from His mother's arms. He is turned towards a lamb and seems to be embracing it. His mother, almost getting up from the lap of St. Anne, is clinging on to the Child, trying to pull Him away from the lamb (a sacrificial animal that stands for Christ's Passion). St. Anne, slightly rising up, seems to want to hold her daughter back so that the latter cannot separate the Child from the lamb. Perhaps Anne represents the Church which does not want anything to stand in the way of Christ's Passion. These figures are all in their natural size but there is room for them in the small cartoon because they are either sitting or bent forwards, and it is almost as though they are layered one behind the other from right to left."

In all probability Novellara's description – with its interesting religious interpretation of the picture – is of a cartoon Leonardo made for the painting now in the Louvre. However, the execution and completion of this painting on the basis of this cartoon can only have taken place some years later – even if both the composition and the facial types found in the *Virgin and Child with St. Anne* and in the 'Burlington House Cartoon' begun in 1499 bear a certain similarity to each other and most likely date from the same period. One cannot help but notice in both works that there is scarcely any age difference between Mary and her mother. Moreover, in the painting in Paris, the bodies of the two women seem to merge into each other. In this painting Leonardo has created a sequence of figures that relate to each other in such a way that it almost looks as though Mary and Anne are sharing the same body, shown in different stages of one movement. The, at first sight, odd lack of any apparent age difference between mother and daughter adds to the impression of there only being one body, of which even the infant Jesus is a part. Furthermore, Mary and Anne's feet – the three that we can see – are positioned with such rhythmic regularity as to be almost artificial, which in itself makes it all the harder for the viewer to distinguish the two figures and their limbs from each other. Particularly startling is the position of Mary's right foot, to the right of Anne's left foot. At first glance it seems that Mary has crossed her legs rather strangely. It is only on closer examination that the disposition of the figures becomes clear and that the viewer, having worked out the various movements, can properly recognise the situation and its meaning: the compositional interconnection between the figures and the similarity in age between Mary and Anne underline the close blood relationship between Anne, Mary and Christ. At the same time the intimacy of the scene raises the status of the two women who are, after all, stage centre, while Christ is slightly to one side.

Besides the wealth of movement in the *Virgin and Child with St Anne*, the painting is also striking for the mountainous landscape behind the figures, which

*Drapery Study for the Virgin and Child with St. Anne*, c. 1503 or c. 1517
Black chalk, Indian ink heightened with white, 230 x 245 mm
Paris, Musée du Louvre

seems almost to have been raised up somehow. It extends across the entire background and takes up approximately a third of the picture surface. The peaks disappearing in the misty distance form a very high horizon and towards the right of the picture even rise up higher than Anne's head. Thus the background seems more dominant and consequently more monumental than in earlier paintings by Leonardo and his contemporaries. This tendency towards the monumental may be connected with the geological and hydrological studies the artist had been making, or possibly with his views on the eternal cycle of Nature. Whatever the case, Leonardo here amply demonstrates the powers of artistic imagination and painterly skills which he described in his *Treatise on Painting* as follows: "If the painter wishes to see beauties that would enrapture him, he is master of their production [...]. If he wishes to produce places or deserts, or shady and cool spots in hot weather, he can depict them. [...] If he seeks valleys, if he wants to disclose great expanses of countryside from the summits of high mountains, and if he subsequently wishes to see the horizon of the sea, he is lord of them, or if from low valleys he wishes to see high mountains, or from high mountains see low valleys and beaches. In fact, therefore, whatever there is in the universe through essence, presence or imagination, he has it first in his mind and then in his hands" (fol. 5r). It is also viable here to interpret the landscape in terms of religious symbolism: individual elements like the barrenness of the largely untouched land, the clear, bright light, the luminous atmosphere and the cool mist which the heat of sun is burning off, are familiar from Marian prayers of supplication at that time. They were regularly referred to in daily prayers and understood as metaphors for Mary, who miraculously gave birth to the Baby Jesus without losing her virginity.

An even intenser mountainous landscape and radiant sky are to be found in the *Virgin and Child (Madonna of the Yarnwinder)* which Leonardo began in spring 1501 for Florimond Robertet, Secretary to the King of France. This small painting with a very youthful Madonna and the Child is known in several versions, of which at least two are regarded as the work of the master himself. It focuses both on Mary's love for her child, showing her gazing gently down at the infant, and on the future Passion of Christ: infant Jesus is completely occupied with a yarnwinder which, by virtue of its similarity to a crucifix, is regarded as a symbol of his later death. It seems that Mary wants to draw the Child back from the yarnwinder, and her left hand is placed tenderly round his body, but even Mary can do nothing to prevent the Crucifixion which Christ is destined to suffer: the Child turns away from his mother's loving gaze, and has no contact at all with her right hand, raised in protection, for his entire attention is directed towards the symbol of his future Passion.

Leonardo's work on the *Virgin and Child with St Anne* and on the Madonna for Florimond Robertet gives the impression that in the early days of the 16th century he was painting with considerable élan. And yet the opposite was the case, because at this time he was mainly occupied with other things such as mathematics and geometry, for instance. Astonished and irritated, Leonardo's contemporaries describe either his unwillingness to paint at all or his immense slowness in completing commissions: the general view was that if there were to be a competition for the slowest painter Leonardo would win hands down (Beltrami, 143). In the summer of 1502, however, he turned his attention to a completely different sphere of activity and took up a position as military engineer to General Cesare Borgia. He then spent almost a year travelling with this notorious figure, mainly in Central

PAGE 68:
*Study of a Bust of a Woman,* c. 1501
Red chalk on pink prepared paper,
221 x 159 mm
Windsor, Windsor Castle

PAGE 69:
*Madonna of the Yarnwinder,* 1501
Oil on wood, 50.2 x 36.4 cm
Private collection

The attribution of this small-format painting is controversial. It was made for a commission from Florimond Robertet, Secretary to the King of France.

Italy. He used these journeys to make a whole variety of studies and, amongst other things, provided his master with topographical drawings whose main purpose was no doubt connected with military strategy. Cesare Borgia's military campaigns required precise knowledge of the terrain, which he was able to acquire from Leonardo's vivid and precise bird's-eye views. However, the artist's employment with Cesare Borgia soon came to an end in early 1503, at which point he returned to Florence and spent another short period there as a painter.

***Bird's-Eye View of a Landscape,*** 1502
Pen, ink and watercolour, 338 x 488 mm
Windsor, Windsor Castle

In all likelihood Leonardo made landscape drawings of this kind for Cesare Borgia's military campaigns.

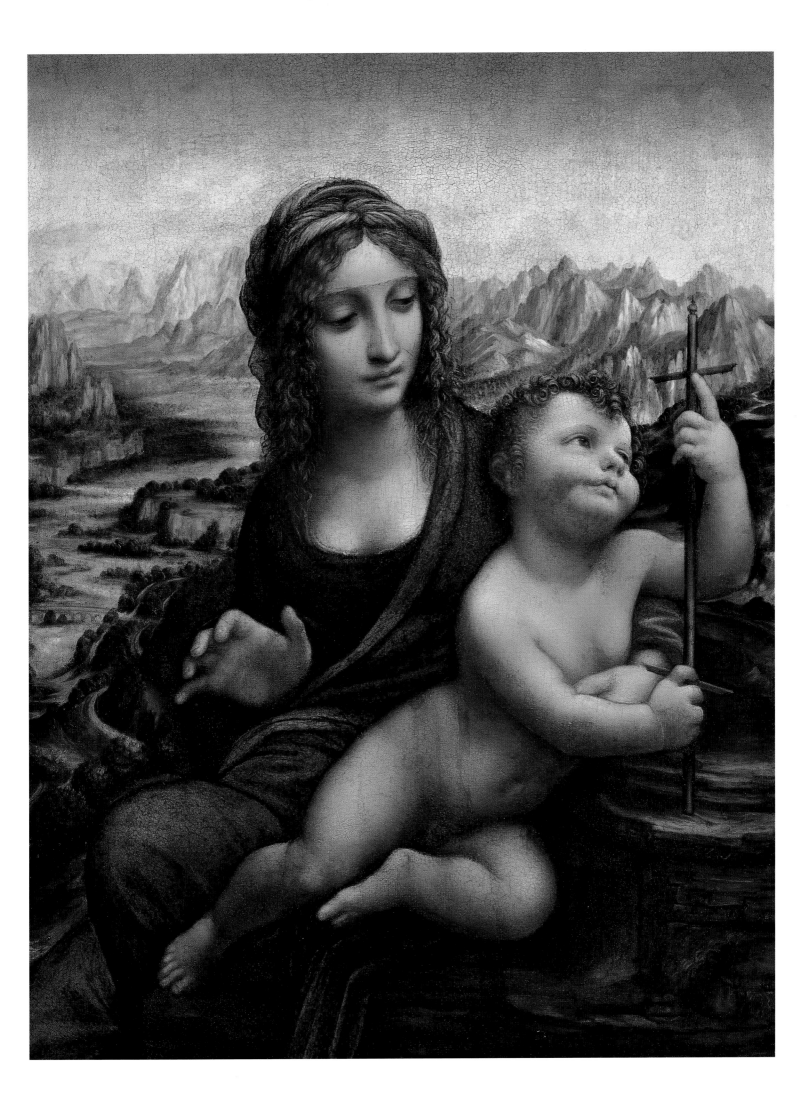

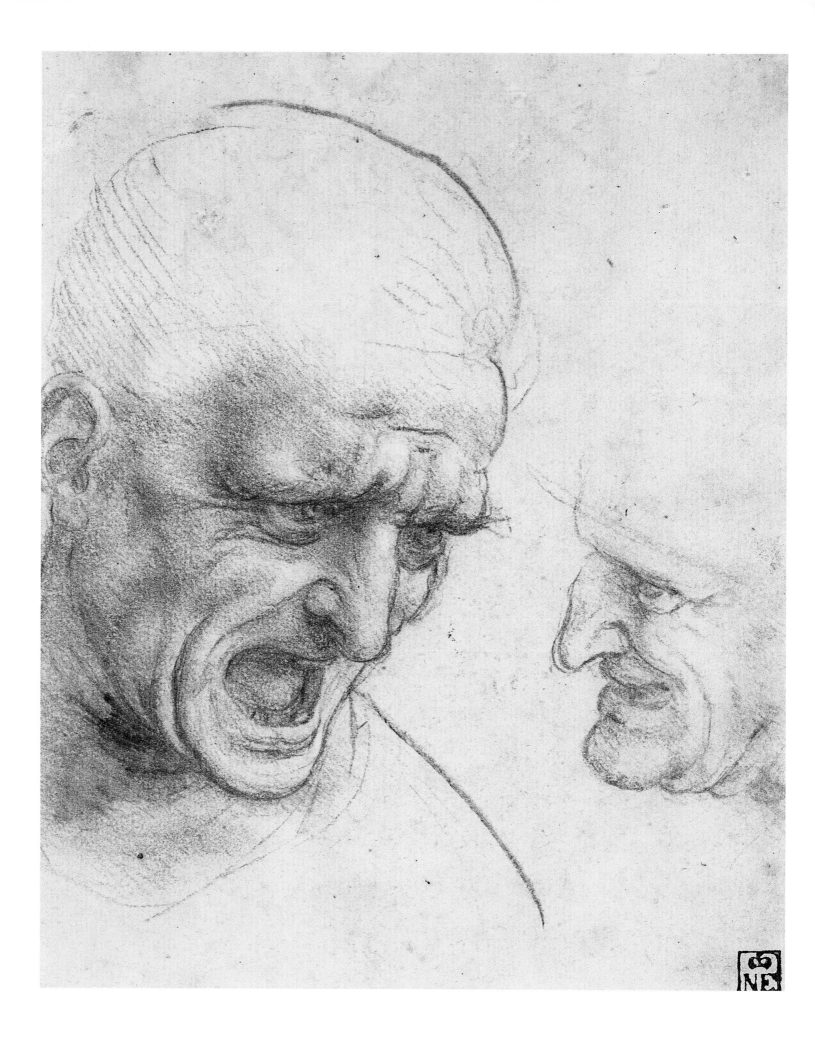

# The Battle of the Giants:
# Leonardo and Michelangelo

In Florence Leonardo soon met the other two outstanding artists of the Florentine High Renaissance: Michelangelo Buonarroti and Raphael. A productive rivalry soon developed between Leonardo and Michelangelo who was younger by almost a whole generation. Both artists, in direct competition with each other, submitted proposals for the wall-paintings in the Council Chamber in the Florentine Palace of Government. Even before this remarkable meeting of two wholly opposed artistic temperaments, Leonardo had already started his portrait of Lisa del Giocondo, who was born in 1479 (illus. p. 73). Since the mid–19th century this has been regarded as Leonardo's best known work and, ever since it was stolen from the Louvre in 1911 by an Italian decorator and rediscovered in curious circumstances in Florence in 1913, it has been regarded as the most famous picture in the world – and has been often interpreted. Various views have been put forward: it is not a portrait of a woman at all but a self-portrait by Leonardo and reveals his homosexual leanings. Or, if it is of a woman, then she is suffering from syphilis or is pregnant or at the very least paralysed down one side of her face. Even easily disproved claims have been put forward with little hesitation: the picture is in bad condition, is damaged and has been brutally cut into at the edges. Of course, there is no truth whatsoever in any of these. The picture is in excellent condition, the open-minded viewer is not likely to find traces of sickness or paralysis in the face of the Mona Lisa. Moreover, there is little need for such mysterious interpretations in view of the fact that we are relatively well informed about the genesis of this painting. Lisa del Giocondo's husband, a well-to-do Florentine silk-merchant was acquainted with friends of Leonardo's family, and this may have been the connection that led to Leonardo's receiving the commission. The reasons for having a portrait painted at all were very clear. In spring 1503 Francesco del Giocondo had acquired a new house for his young family, and a few months before that his wife Lisa had brought a son, Andrea, into the world – reason enough in 15th or 16th century Florence for commissioning a portrait.

In terms of form, Leonardo's *Mona Lisa* clearly demonstrates various aspects of Florentine and Umbrian portraiture in the late 15th century (which in turn bore a certain allegiance to Flemish portraiture). The half figure is turned two-thirds towards the viewer, a balustrade with pillars connects the foreground with the landscape in the background. But Leonardo went far beyond the traditions he was drawing on: in the *Mona Lisa* the subject comes closer to the front edge of the picture than had been customary hitherto. This smaller distance between sitter and viewer heightens the intensity of the visual impression while the landscape suggests greater spatial depths and atmospheric intensity. Craggy mountains disappear

***Study of a Face for a Warrior in the Battle of Anghiari,*** 1503
Red chalk, 227 x 186 mm
Budapest, Szépmüvészeti Múzeum

This study by Leonardo was used for the profile of the first Florentine horseman (from the right) in the Battle of Anghiari.

PAGE 70:
***Study of a Face for a Warrior in the Battle of Anghiari (Niccolò Piccinino),*** 1503
Silverpoint, black and red chalk
192 x 188 mm
Budapest, Szépmüvészeti Múzeum

This expressive study is close to the final version of the face of Niccolò Piccinino, the leader of the Milanese troops, who were defeated by the Florentine forces in the Battle of Anghiari.

 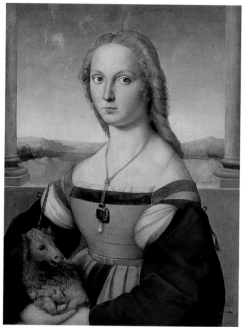

Lorenzo di Credi
*Portrait of a Woman,* c. 1490
Tempera on wood, 75 x 54 cm
Forlì, Pinacoteca civica

Leonardo drew inspiration for the *Mona Lisa* from this style of portraiture which was developed in Florence.

Raphael
*Lady with the Unicorn,* c. 1504
Oil on wood, 65 x 51 cm
Rome, Galleria Borghese

In this and other portraits for Florentine clients the young Raphael was following the lead given by Leonardo in the *Mona Lisa.* The unicorn – a mythical creature which only virgins may touch – was regarded as a symbol of virtue.

into the distance against a greenish-blue sky. On the left we can make out a path and on the right we can see what looks like a dry river-bed, although it is not possible to tell quite how this connects, if at all, with a reservoir higher up. Individual outcrops in the landscape, bereft of vegetation, are reminiscent of similar rock formations in religious pictures that Leonardo had begun not long before. Indeed, the formal affinity between this work and depictions of the Madonna cannot be dismissed, as is frequently the case in Renaissance portraits of women. The Mother of God was regarded as the ideal to which every honourable woman would aspire, and this is reflected in the formal parallels between depictions of the Madonna and portraits of women. Even the smile of the *Mona Lisa* is related to the smiles of St. Anne and of the Virgin: indeed a smile of this kind was part of the standard repertoire of painters in the late 1400s and early 1500s. In addition, the Mona Lisa's smile also matches contemporary views on feminine charm: the beauty of a contented, modest female smile was a reflection of that woman's beauty and, hence, also of her virtue. Beauty was taken in those days to be an expression of virtue, external beauty was an embellishment of virtue – as demonstrated earlier by Leonardo in his *Portrait of Ginevra de'Benci* (see pp. 19ff.). And even apart from this, we ought not to forget Lisa del Giocondo's situation, for having made such an advantageous marriage she perhaps had every reason for smiling: she herself came from a considerably less wealthy family than her husband, who turned out to be an attentive and caring spouse. Lisa had "married well" – already in those days good grounds for smiling out into the world.

The outstanding painterly quality of this portrait derives primarily from its meticulous detail. A gossamer veil covers the subject's free-flowing hair; her dark gown, particularly below the neckline, is covered with intricate embroidery and is gathered vertically. The heavier-looking fabric of the mustard-coloured sleeves shimmers with its own natural gleam. In particular in the face and hands shading is used to create an utterly convincing impression of plasticity. The evocative impact of the portrait is due largely to its three-dimensionality plus the artistry of the pictorial light in the landscape which causes the subject to stand out as she does. In view of this, one has to imagine that her face is lit by some other source closer to the viewer.

PAGE 73:
*Portrait of Lisa del Giocondo
(Mona Lisa),* 1503-1506
Oil on wood, 77 x 53 cm
Paris, Musée du Louvre

The most famous painting in the world was made for the Florentine silk merchant Francesco del Giocondo, who commissioned it to mark his setting up a new home and the birth of his son, Andrea.

***Sketch for the Battle of Anghiari*** (detail),
1503
Pen and ink, 101 x 142 mm
Venice, Gallerie dell' Accademia

Unknown artist
***Battle of Anghiari after Leonardo
(tavola Doria),*** 1503-1506
Oil on wood, 85 x 115 cm
Private collection

This very reliable copy shows the unfinished
state of the wall-painting after Leonardo left
Florence in 1506.

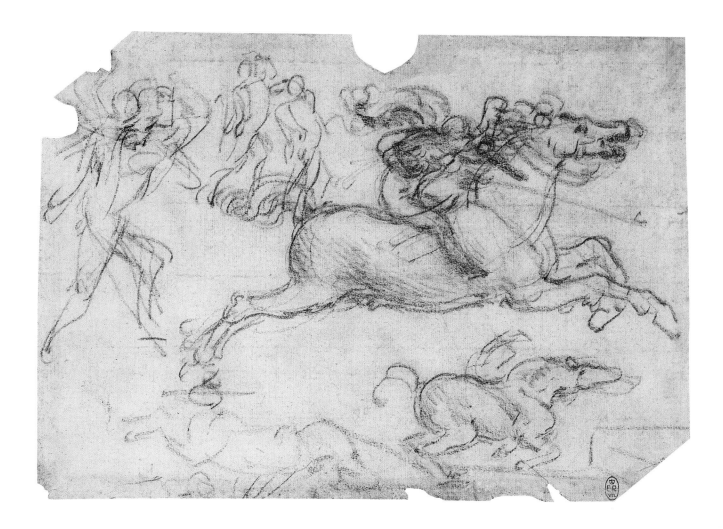

*Sketches of Galloping Horsemen and Other*
*Figures,* c. 1503-1504
Red chalk, 168 x 240 mm
Windsor, Windsor Castle

Even before it was finished the portrait of Lisa del Giocondo had a major influence on Florentine painting. The young Raphael, who repeatedly visited Leonardo's workshop, immediately adopted the older master's schema and, on the basis of the *Mona Lisa*, created a form of portraiture that was to hold good for decades. Unlike Raphael, who rapidly produced the new type of portrait for his Florentine clients, Leonardo never delivered his portrait of Lisa to his client, Francesco del Giocondo. Already in autumn 1503 he received a much more important commission to paint the Grand Council Chamber in the Palazzo Vecchio, the seat of government in Florence. He postponed finishing the portrait to a later date.

The wall-painting for the Palazzo Vecchio, which Leonardo left unfinished in spring 1506 and which was destroyed in the mid-16th century, depicted the Battle of Anghiari of 1440, when Florentine forces, together with their papal allies, defeated their Milanese opponents near the town of Anghiari. The intention had been to juxtapose this with Michelangelo's so-called *Battle of Cascina*, which depicted the raising of the alarm in July 1364 that warned the Florentine troops of the approaching enemy and led to their emerging victorious from the skirmish. These two paintings, which are only known from contemporary copies, would have constituted by far the most impressive decoration of any public interior in the early 16th century. The dynamism and drama of Leonardo's composition, which bears formal similarity to a Classical cameo with a fall of Phaeton (illus. p. 76), shine through both in his sketches and in contemporary copies. These sketches and copies show four riders fighting furiously for a flag and its pole: at the left is Francesco Piccinino and his father Niccolò, the leader of the Milanese troops. They are opposed by Piergiampaolo Orsini and Ludovico Scarampo – from the allied papal and Florentine troops, who were to triumph in the conflict and with

Unknown artist before 1550/
Peter Paul Rubens c. 1603
***Copy of the Battle of Anghiari by Leonardo***
Black chalk, pen and ink heightened with
lead white, over-painted with watercolour,
452 x 637 mm
Paris, Musée du Louvre

The finest copy of the Battle of Anghiari was
made in the mid-16th century and was then
extended at the edges in the early 17th
century by Peter Paul Rubens, who also filled
in the sword of the fourth horseman.

***The Fall of Phaeton***
Antique cameo from the Medici collection
(Line drawing after Müntz)

This antique cameo was the formal model for
Leonardo's battle scene.

whom contemporary viewers in Florence would have been expected to identify. But it is the riders on the left who capture one's attention, for here – as so often – evil and hostility exercise a greater fascination than goodness. The two riders on the left, above all Francesco Piccinino, display uncontrolled wrath in their positively distorted features. In Francesco's case, his brutal grimace goes with a strange contortion of his upper body and oddly placed left hand. It is even as though his torso were merging into the body of the horse. Man and beast become one, the combatant becomes a beast: a misshapen creature whose unbridled frenzy is reflected in its contorted body. The opponents from the Florentine troops and papal allies are less dramatic in their forms. Admittedly there is nothing peaceable about their movements but their profiles are much less extreme and their bodies are not wrenched out of position. They represent a different, more balanced view of combat, which Leonardo's contemporaries already found much less interesting, preferring the negative embodiments of abandoned belligerence in their opponents.

The effect of the fury expressed in the faces is further heightened by the unmistakable, central iconographic importance of the depiction of Francesco Piccinino whose armour bears several of the attributes of Mars, the god of war. The ram on his chest is a symbol for Mars, and the horns of Amun on his head and the ram-skin on his body are both traditionally associated with Mars. The leaders of the Florentine troops, approaching from the right – and by no means similarly in the grip of combative fury – represent the notion prevalent in Florence at the time, of implementing carefully considered tactics on the field of battle. In some copies (see p. 74) there is a dragon as a symbol of circumspection and intelligence, in almost all the others there is a mask of Minerva, the goddess in Classical literature who would add cool reason to a military campaign and who, alone, could overcome Mars and prevent him from acting with rash thoughtlessness.

In the dramatic depiction of conflict the contrast between the two artists' designs could hardly have been greater. Leonardo focused on the violent encounter of

opposing forces and marked out the warring factions with recognisable attributes. Michelangelo, on the other hand, largely avoided identifying his figures and devoted his attention to the expressive depiction of the nude male form, having already experimented with this in the marble statue of David he finished in 1504. Leonardo seems to have been impressed, despite himself, by the 'muscular rhetoric' of his successful, young rival: the one surviving drawing by Leonardo of a contemporary artwork is of Michelangelo's *David* (illus. p. 78). Not long afterwards Leonardo once again started to make studies of muscular, male nudes (illus. p. 79). Only a few years previously he had been sharply critical of depictions of exaggeratedly muscular male forms, since they too readily resemble a "sack of nuts" or even a "bundle of radishes" (fols. 117–118v). This change of heart was connected with the rise of the young Michelangelo: now there was no longer a demand for the smooth lines of the figures of the 15th century, for this had given way to the heroic style of the High Renaissance, which the Florentine painter and sculptor was to elevate to a new ideal with his depictions of powerful male bodies. In the battle of the giants it seems that Michelangelo, the younger of the two, impressed Leonardo rather than vice versa.

Aristotele da Sangallo
*Copy after Michelangelo's cartoon for the so-called Battle of Cascina* (1504/05), c. 1542
Grisaille, 76.4 x 130.2 cm
Holkham Hall, Collection of the Earl of Leicester

This early 16th century copy of Michelangelo's so-called Cascina Cartoon shows the young artist's interest in portraying the male nude.

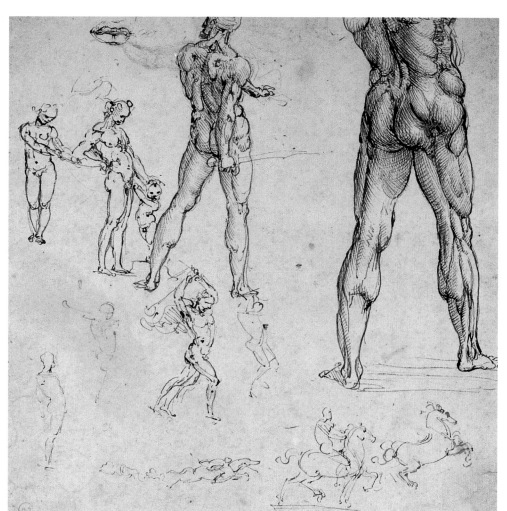

PAGE 79:
***Studies for the Legs of a Man and of a
Horse,*** c. 1506/07
Pen and ink over red chalk on red prepared
paper, 285 x 205 mm
Windsor, Windsor Castle

***Studies for the Exterior Anatomy of the Male
and for Other Figures,*** c. 1504–1506
Pen on reddish tinted paper, 253 x 197 mm
Turin, Biblioteca Reale

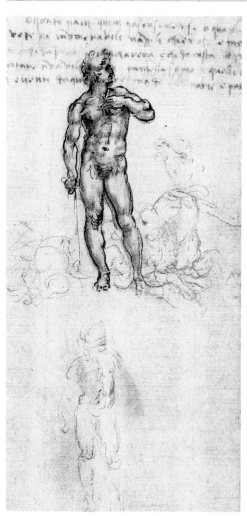

***Drawing after Michelangelo's David***
(detail), 1504
Pen, ink and black chalk, 270 x 201 mm
Windsor, Windsor Castle

Michelangelo
***David,*** 1501-1504
Marble, Height 4.10 m
Florence, Galleria dell' Accademia

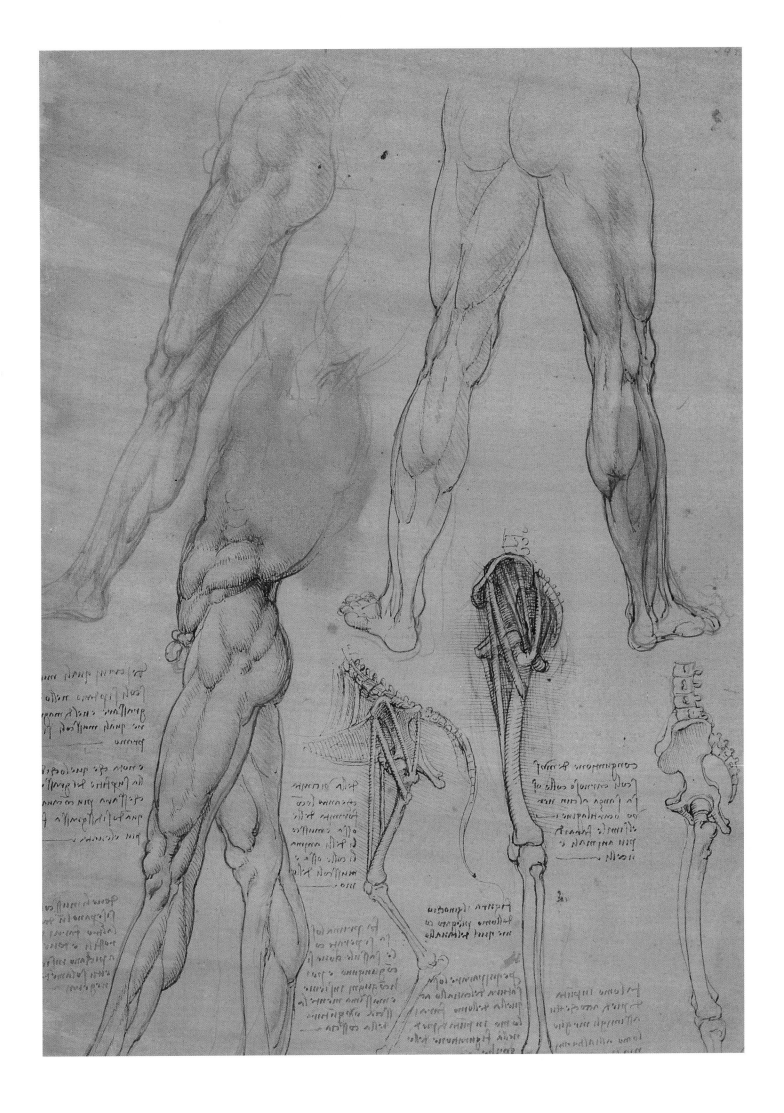

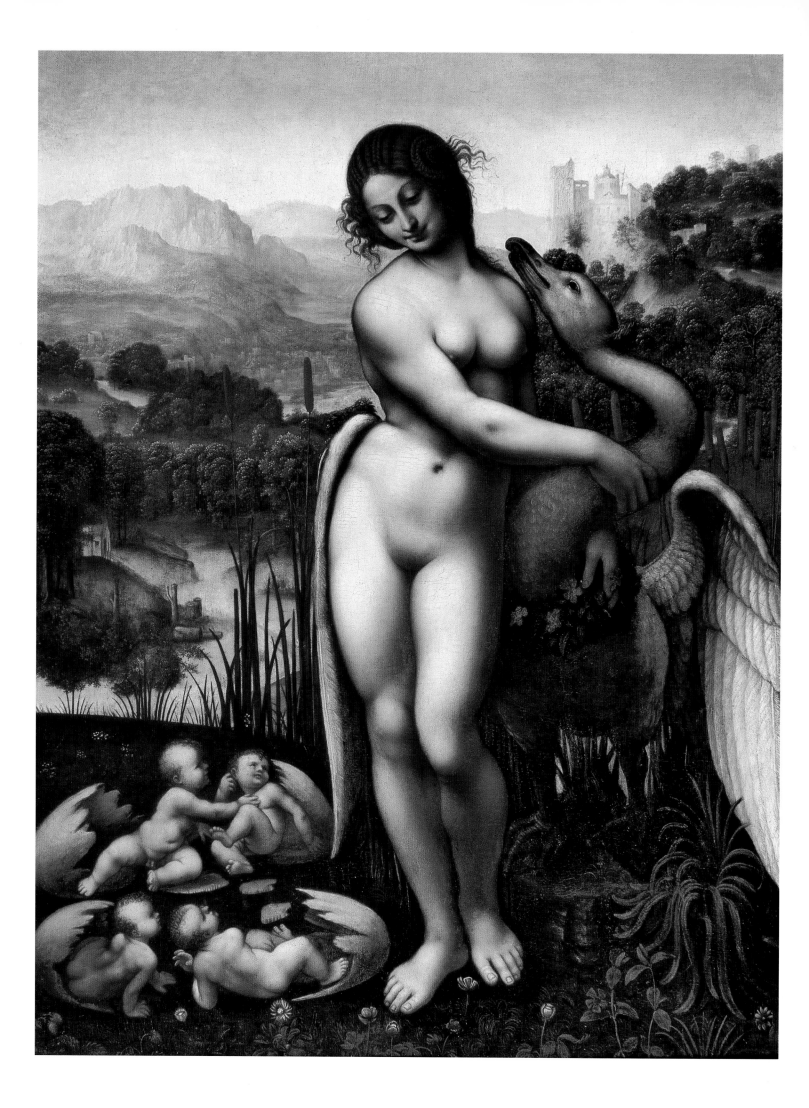

# The Last Years

Like so many other works, the *Battle of Anghiari* was also left unfinished by Leonardo. He does not even seem to have made any very great effort to finish this monumental wall-painting: the technique he was using soon proved to be problematic and the wall-painting was already showing signs of wear even before it was finished. From Vasari we also know that Leonardo was annoyed by the petty attitude taken by his clients in the matter of payment. With the help of a written statement by Charles d'Amboise, the French governor of Milan, in May 1506 Leonardo was granted three months' leave from his duties in Florence. Having travelled to Milan, he then stayed there much longer than intended: legal disputes regarding the *Virgin of the Rocks* had to be put aside and he had to make a copy of the painting for the Confraternity of the Immaculate Conception since the first version had been removed from the altar and was now in new ownership. In August 1508 he was able to give the Brothers the second version of the *Virgin of the Rocks*, which is now in London. By now Leonardo was already working regularly for the French rulers in Milan, and was also paid better by them than by previous patrons. However, we only have an extremely patchy knowledge of what he produced or of what else he did during the ensuing years in Milan. While he was still in Florence he had taken up his anatomy studies again, and he continued these in Milan and later on still in Rome, too. Apart from that he designed decorations for festivities at the French court in Milan, made himself useful as an architect, contributed ideas to the extension of the irrigation system and worked on unfinished works such as the *Virgin and Child with St. Anne*. This was most probably also the time when he painted *Leda and the Swan*, which is only known to us through a number of copies. Leonardo evolved his *Leda* from a number of older sketches. In the earliest of these he concentrated primarily on the figure of Leda kneeling in a similar manner to the figure of St. Hieronymus (illus. p. 22). Over the following years, Leonardo took the slightly bending figure of Leda – being tenderly importuned by the swan – and turned her into a standing nude, albeit without changing the iconographic meaning. The drawings and the copies of the painting alike focus on the amorous adventures of the Father of the Gods, Zeus, who used to pursue young women (sometimes even young men) in the guise of a wild creature or in some apparently unsuspicious, non-erotic form: in Leda's case, as we know, he came to her as a swan. In one of the drawings Zeus has laid his wing lovingly against Leda, and she is turning to him tenderly, touching his head gently with her left hand. Her right hand points to the little ones who have just slipped out of their eggs.

***Study for the Kneeling Leda,*** c. 1508
Black chalk, pen and ink, 125 x 110 mm
Rotterdam, Museum Boymans-van-Beuningen

This drawn version of a kneeling Leda and the painting shown next to it have one thing in common: an abundance of bulrushes as phallic symbols.

PAGE 80:
Cesare da Sesto (?) after Leonardo
***Leda and the Swan,*** c. 1505–1510
Oil on wood, 69.5 x 73.7 cm
Salisbury (England), Wilton House, Collection of the Earl of Pembroke

Leonardo's original painting of *Leda and the Swan* is believed lost. It is known through written sources and a number of copies.

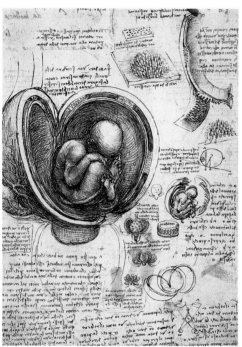

*The Foetus in the Womb,* c. 1510–1512
Pen and ink with wash over black chalk and
red chalk, 305 x 220 mm
Windsor, Windsor Castle

During the last years of his life Leonardo
turned once again with much enthusiasm to
the human anatomy.

*The Neck and Shoulder of a Man*
c. 1509/10
Pen and ink, 292 x 198 mm
Windsor, Windsor Castle

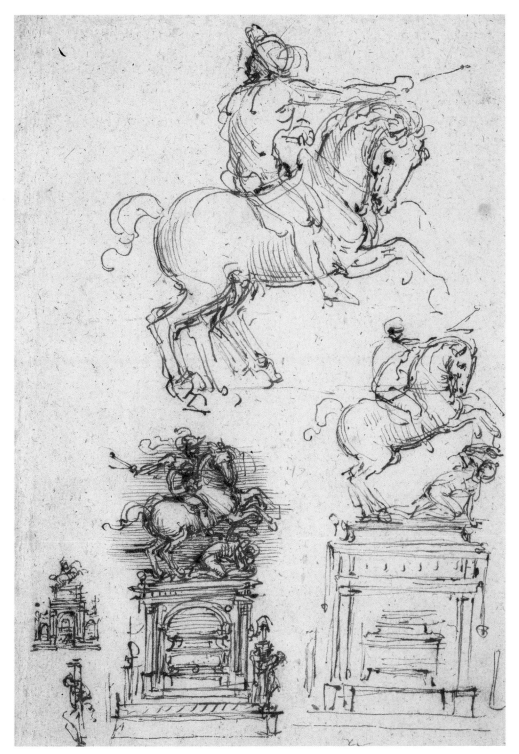

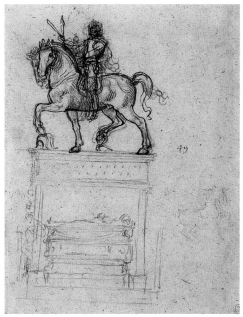

***Studies for the Trivulzio Monument,***
c. 1507–1509
Pen and ink, 280 x 198 mm
Windsor, Windsor Castle

In his designs for a tomb for Giangiacomo
Trivulzio Leonardo took up ideas from his
earlier plans for an equestrian monument for
the Sforza family in Milan. The expressive
power of the rearing horse anticipates the
dynamism of later Baroque equestrian statues.

***Study for the Trivulzio Monument,***
c. 1508–1512
Pen and ink and red chalk, 217 x 169 mm
Windsor, Windsor Castle

In the last version of the designs for the
equestrian monument Leonardo somewhat
lessened the dynamism of the composition.

***Young Woman (so-called Pointing Lady),***
c. 1516
Black chalk, 210 x 135 mm
Windsor, Windsor Castle

PAGE 85:
***St. John the Baptist,*** c. 1513–1516
Oil on wood, 69 x 57 cm
Paris, Musée du Louvre

Controversy surrounds both the attribution
and the date of this painting, whose 'sfumato'
technique is believed to have been primarily
evolved by Leonardo: numerous glazes create
an equal number of degrees of shading, with
the result that the figure of John seems to
emerge, radiant with light, from out of the
darkness.

The version known to us in paintings is more monumental in its effect and the
swan also appears to be more insistent. The creature is now standing upright,
extending its neck upwards and holding the young woman firmly with one wing.
Meanwhile Leda is turning away from her lover, with her eyes lowered, yet hold-
ing him with both hands. Above all, the frontal view of the female nude figure
underlines the erotic quality of the painted versions. Furthermore, her pose and the
striking plasticity of her rounded limbs and body are highly reminiscent of Classi-
cal statues of Venus and, therefore, of love. The erotic quality of the subject mat-
ter is also evident in the middle-ground which, both in the drawings and in the
paintings, has numerous bulrushes, *typha latifolia*, to give them their correct
botanic name. These bulrushes have densely filled seedheads, which then burst so
that the seed scatters far and wide on the ground and on the water – nature's mas-
terplan to ensure the continued existence and increase of the bulrush population.
The sexual connotations of this plant, and by implication of the picture itself,
could hardly be clearer.

As a painter and engineer in Milan Leonardo had the opportunity to revive his
plans for an equestrian statue, although now no longer for the deposed Ludovico
Sforza, but for General Giangiacomo Trivulzio, who had played a decisive part in
the taking of Milan as commander of the French troops. Trivulzio had set aside a
large amount of money to provide for a worthy memorial after his death. Most
likely impressed by the ambitious designs which Leonardo showed him in the
summer of 1507, he abandoned his originally more modest plans in favour of a
monumental tomb. Initially Leonardo turned once again to the fascinating idea of
a wildly rearing horse, which seemed more viable in light of the smaller dimen-
sions of the Trivulzio monument (illus. p. 83). Compared with his earlier designs
for the Sforza monument, he actually increased the dynamism of the movements
of horse and rider, particularly by intensifying the expressive power of the body of
the horse. Leonardo underlines the monumentality of the design by creating a tall
plinth which was intended to have a sculpture in the centre and a pillar at each
corner with the sculpted figure of a prisoner tied to it. Thus Leonardo's designs
were similar to Michelangelo's first designs for the tomb of Pope Julius II, and
intended to be of a comparably high standard. Nevertheless, despite these aspira-
tions and Leonardo's impressive designs, after years of planning in the end Trivul-
zio decided against the project. As before in the case of the Sforza monument, cir-
cumstances prevented the realisation of an equestrian monument which would
have far outshone all existing examples of the species.

During his second stay in Milan, Leonardo was less and less active as a painter.
It seems that painting was giving way to anatomical drawings, which – in their
pictorial immediacy and perfection – seem like an alternative form of artistic
expression. Unlike the early anatomical drawings Leonardo made when he was
first in Milan, these later studies are based much more extensively on dissections
of the human body. Having made his own exact observations Leonardo now dis-
tanced himself from much of what was contained in the textbooks that had previ-
ously been a major influence on his views (erroneously believing for instance that
there was a connection between the testicles and the brain, see pp. 40f.). He con-
centrated increasingly on the muscles and sources of movement, providing impres-
sive proof of his acute talent for observation and drawing. His precise illustrations
of anatomical details were largely restricted, however, to the surface of the human
anatomy, the musculature and the bone structure. His investigations into the

*Bird's-Eye View of the Italian Coast by Terracina,* c. 1515
Pen and ink and watercolour, 272 x 400 mm
Windsor, Windsor Castle

This large-format drawing was no doubt made in connection with the papal project to drain the Pontini Marshes south of Rome. The place-names (such as the present-day resort of Terracina) are written in the hand of a pupil of Leonardo's.

deeper layers of the body left something to be desired as far as accuracy was concerned – in all likelihood because of the immense technical difficulties that he had to overcome in his ground-breaking research. Thus he was able to draw a four to five month-old foetus, but in order to show the womb around it, he had to rely on what he knew of animal anatomy (illus. p. 82). When it came to the anatomy of the heart he adopted a similar procedure, basing some of the details on cows' hearts. Nonetheless, for centuries Leonardo's studies were the most precise anatomical drawings anywhere, admired by the few who were fortunate enough to see them, but so far ahead of their time that they were of no immediate use to medical practitioners.

Leonardo's sojourn in Milan was largely dependent on the favour of the French governor Charles d'Amboise, who died suddenly in 1511. Once again the artist had lost an important patron and thus, in September 1513, accepted the protection of Giuliano de' Medici, with whom he then travelled to the papal court in Rome. Shortly before this, Giuliano's brother, Giovanni, had succeeded to the Throne of St. Peter as Pope Leo X and it must have seemed to Leonardo, by now 61 years old, that there was a good prospect of his becoming court artist to the newly elected Pope. But his hopes were to be dashed. In the papal court in Rome Leonardo had trouble with insolent German craftsmen, and received no major commissions for paintings comparable to those already carried out by Raphael and Michelangelo. Nevertheless, he did throw himself into Leo X's project to drain the Pontini marshes south of Rome. To this purpose he executed an extremely detailed drawing of the relevant terrain. Besides this he conducted a number of experiments that seemed rather strange to his contemporaries and which Vasari describes as follows: "Leonardo used to get the intestines of a bullock scraped completely free of their fat, cleaned and made so fine that they could be compressed into the palm of one hand; then he would fix one end of them to a pair of bellows lying in another room, and when they were inflated they filled the room in which they were, and forced anyone standing there into a corner. [...] He perpetrated hundreds of follies of this kind, and he also experimented with mirrors and made the most outlandish experiments to discover oils for painting and varnish for preserving the finished works."

PAGE 87:
*John the Baptist* (with the attributes of Bacchus), c. 1513–1516 (?)
Oil on canvas (transferred from panel), 177 x 115 cm
Paris, Musée du Louvre

The attribution of this work to Leonardo is as controversial as ever. Originally painted as a depiction of John the Baptist, the attributes of Bacchus were added in a later era.

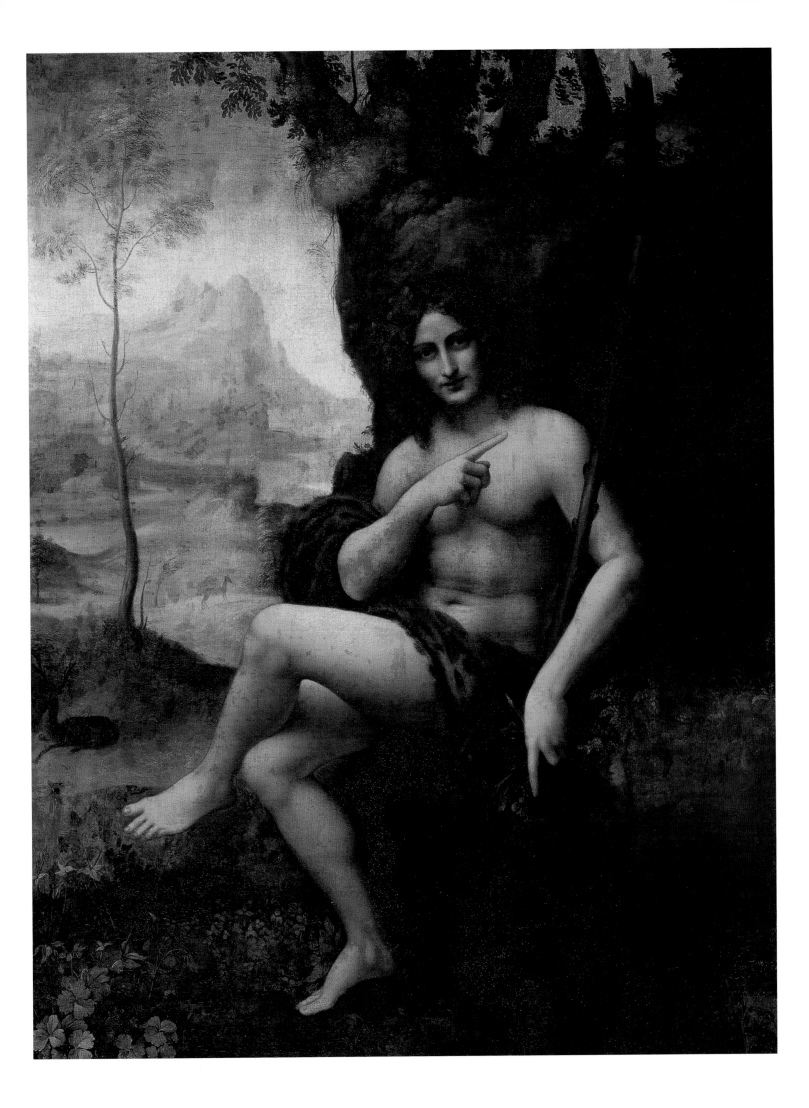

***Studies of Cats, a Dragon and Other
Animals,*** c. 1513–1515
Pen and ink and wash over black chalk,
271 x 204 mm
Windsor, Windsor Castle

This so-called 'multiple cat-drawing' goes
with the 'multiple horse-drawing' and is
evidence of Leonardo's plans for a treatise on
the movements of animals.

***Study of Horses, a Dragon and the Combat
between St. George and the Dragon,*** c. 1517
Pen and ink over black chalk, 298 x 212 mm
Windsor, Windsor Castle

An accompanying note to the so-called 'multiple
horse-drawings' contains remarks on the basic
possibilities of movements of animals.

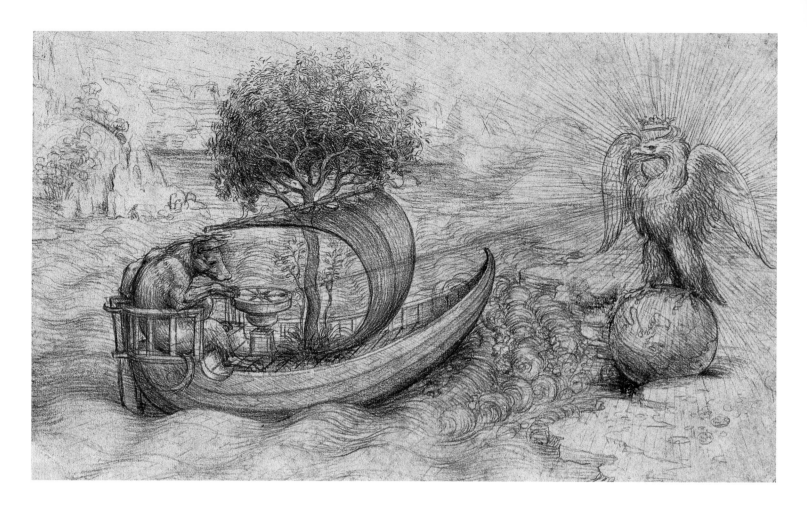

It is probably these experiments with paints and varnishes to which we owe one of the last paintings that can be attributed to Leonardo, his portrayal of *St. John the Baptist* (illus. p. 85), which is an impressive example of Leonardo's use of *sfumato*. By applying numerous layers of thin, translucent varnish, the artist can create a whole range of shadows in the picture, blurring contours into soft transitions between light and shade, and increasing the plasticity of the figures. The painterly effect achieved through this process is derived from experiments with oils which allow the differentiated application of layer upon layer of paint so that it is possible to create a virtually monochrome portrayal of the subject which relies on fine nuances of light and shade alone. In the painting of *St. John the Baptist* the use of *sfumato* adds an interesting dimension to the meaning of the painting: the figure of the Baptist emerging from out of the almost black background seems to be made of light; the scene must be illuminated by a light source beyond the pictorial space, which is in itself completely in keeping with the subject matter, for John the Baptist is not the source but only the witness of God's light which is shining on him. Thus the painting gives visual form to the first verses of the Gospel according to John which describe the one who was sent to bear witness to the "light that shineth in darkness". Thus Leonardo's use of *sfumato* is not simply an autonomous choice by the artist but also conveys the religious content of the picture. At the same time this technique lends the painting a certain atmospheric intensity which has been exhaustively interpreted, in particular by those with an interest in psychoanalysis. The gentle shadows imbue the subject's skin tones with a very soft, delicate appearance, almost androgynous in its effect, which has led to this portrayal being interpreted as an expression of Leonardo's homoerotic leanings.

   In yet another painting either Leonardo or a pupil of his returned to the subject of John the Baptist, and this same ambiguity arises again (illus. p. 87). In this

*Allegory with a Wolf and an Eagle,* c. 1516
Red chalk, 170 x 280 mm
Windsor, Windsor Castle

The ship with a wolf at the helm is probably an allusion to the Pope in Rome, the eagle with a crown on a globe of the earth symbolises the political aspirations of the King of France. The allegory may well refer to a meeting between Pope Leo X and Francis I, King of France.

work St. John, now full length, is sitting in front of a landscape background, with a view to the left of a river valley and a mountain range. With a gesture of his right hand John is pointing towards Christ, who will follow him. There is also Christian symbolism in the detail of the painting: the deer in the background was regarded as a symbol of Christ and the Baptism, while the columbine in the foreground expresses the Christian hope of redemption which would be achieved through Christ and the sacrament of baptism. But the beautiful, naked youth in the desert was very soon no longer seen only in the light of Christianity. An unknown painter in the 16th or the 17th century added the attributes of Bacchus to the composition: an ivy wreath was added to John's head and the staff in his hand was turned into a thyrsus (the staff carried by Bacchus). This transformation of the saint into a wanton, pagan god highlighted an ambiguity which was already present in the portrayal of John the Baptist, and which Cassiano del Pozzo described in 1625 as follows: "John the Baptist in the desert. The figure, one third less than natural size, is extremely delicate, but not especially pleasing because it does not induce our respect, it is lacking in decorum and likeness."

The sketches for the two paintings of John the Baptist are the most important evidence of Leonardo's sojourn in Rome which already came to an end in 1516. After his patron Giuliano de' Medici died he remained in the Eternal City for a few months more, before accepting an invitation from Francis I to go to the French court in the winter of 1516/1517. Together with pupils and friends Leonardo was given a fine residence in Cloux, not far from the royal château in Amboise, and a remarkably generous salary, although it is not entirely clear what professional activities he undertook in the remaining two years of his life. It seems that he was involved in designing court festivities, in planning an irrigation project in the Sologne (south of the Loire between Amboise and Orleans), and in making drawings for a royal palace in Romorantin, a small town south of Blois.

Leonardo's failing creative powers in his last years were probably linked to ailments brought on by old age mentioned by Antonio de Beatis, secretary to Cardinal Luigi d'Aragona. It is significant that in this letter of 10 October 1517 he referred to the 65 year-old artist as an old man of over seventy, who was not able to do much owing to his partial paralysis, but who could nevertheless still draw well. Leonardo's late drawings would also seem to point to a waning output, and scarcely one of these can be dated with any certainty to the last two years of the artist's life. No paintings at all from this period can be positively identified as being by Leonardo, and we have to assume that Leonardo was simply as unproductive in his last years as so often before. And yet, his last drawings show no signs of the artist's age. Besides perplexing allegories there are depictions of cats, dragons and horses in whimsical motion. More intense and powerful in their composition than the sketches from his youth, these drawings are imbued with an almost childlike energy. They give the impression that despite his advanced years, Leonardo – his mind as lively as ever – was turning back to drawing, to the origins of his own art. In vigorous drawings and depictions of fabulous, unreal creature we still see the full appeal of an artist who has – unaffected by his own age or the passage of time – retained to this day its youthful freshness.

*Fantastic Dragon,* c. 1515–1517
Black chalk, pen and ink, 188 x 271 mm
Windsor, Windsor Castle

# The Life of Leonardo da Vinci

**1452** On 15 April in Vinci Leonardo comes to the world as the illegitimate son of the notary Ser Piero di Antonio da Vinci (b. 1426) and the peasant woman Caterina (also born out of wedlock). That same year Leonardo's father marries a younger woman from a "better background", the sixteen year-old Albiera di Giovanni Amadori.

**1457** According to his grandfather's tax declaration Leonardo lives with his father in the latter's household. In 1457 his natural mother marries the limeburner Accattabriga di Piero del Vacca.

**1469** Ser Piero da Vinci rents a house in the Via delle Prestanze (now the Via dei Gondi) in Florence, and probably that same year or a little earlier his son starts an apprenticeship in the workshop of the respected Florentine painter and sculptor Andrea del Verrocchio.

**1472** According to the custom of the time, the young artist enters the San Luca guild of painters in Florence, which would indicate that he had by now attained a degree of professional independence.

**1473** Leonardo's earliest extant dated drawing, the so-called *Landscape Drawing of the Arno Valley* which is now in the Uffizi in Florence.

**1476** In April Leonardo is anonymously accused of homosexual practices (*sodomia*) with the seventeen year-old painter's assistant Jacopo Saltarelli who was apparently well-known for such things. Although the accusation was repeated in June 1476, there was never any charge – no doubt for lack of evidence.

**1472–1480** Leonardo is still working in the workshop of Andrea del Verrocchio, amongst other things on the latter's *Baptism of Christ* and is probably also already producing smaller format paintings of his own, such as the *Madonna with the Carnation*, the *Madonna Benois* and possibly also the *Annunciation* which is now in the Uffizi.

**1478** In January, most likely through his father, Leonardo receives his first important commis-sion: to create a medium-sized altar painting for the Bernhard Chapel in the Palazzo Vecchio (the seat of government) in Florence. Despite a substantial advance he seems barely to have started the painting, and certainly not to have finished it.

**1478–1480** The young artist, influenced by the Flemish masters, paints the small *Portrait of Ginevra de'Benci* for Bernardo Bembo.

**1481** In March – most likely again through his father – Leonardo is commissioned to paint a

*Portrait of Leonardo,* Woodcut from Vasari's Lives of the Artists, 1568

Jean Gigoux
*Verrocchio Recognises the Greater Talent of his Pupil Leonardo,* 1835
Lithograph, 293 x 233 mm

large altar painting with an 'Adoration' for San Donato a Scopeto, a church attached to a monastery outside the city walls of Florence. Although this is his most important commission so far, Leonardo nevertheless does not complete it, nor a painting of St. Hieronymus, started a little earlier, which was also to have been an altar painting.

**1482** Leonardo moves from Florence to Milan and offers his services as a military engineer, sculptor and painter to the ruler there, Ludovico Sforza.

**1483–1486** Together with the brothers Ambrogio and Evangelista de Predis Leonardo is commissioned to execute an altar painting for the *Virgin of the Rocks.* The three artists probably completed a first version of this in 1486.

**1487–1488** Leonardo is moderately successful as the consultant architect in the Milan Cathedral Workshop.

**1489–1494** Leonardo works on the equestrian statue of Francesco Sforza in Milan, commissioned by Ludovico Sforza. At the same time – by now court artist to the Sforza family – he paints the portraits of Cecilia Gallerani and Lucrezia Crivelli (no longer extant) and makes a name for himself designing court festivities.

**1495–1498** Commissioned by Ludovico Sforza, Leonardo paints the *Last Supper* in the refectory of the Dominican Monastery Santa Maria delle Grazie in Milan. It is also at about this time that he designs the interior of the so-called 'Sala delle Asse' in the Castello Sforzesco.

**1499** In October 1499, shortly after the defeat of his patron, Ludovico Sforza, by French troops, Leonardo presumably begins the 'Burlington

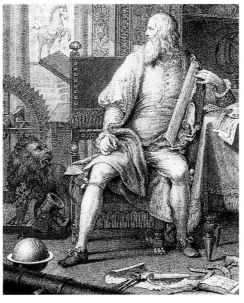

Domenico Cunego
*Leonardo in his Studio in Milan,* 1782
Etching, 320 x 202 mm

House Cartoon' for King Louis XII of France but he already leaves Milan in December. First he stays as the guest of Isabella d'Este in Mantua, paints a portrait of Isabella, but then continues his journey on to Venice.

**1500** In April Leonardo returns to Florence and embarks on what proves to be his most productive period as a painter so far. In spring – according to the account by Giorgio Vasari – Leonardo makes a cartoon of the *Virgin and Child with St. Anne* for the Church of SS.

Annunziata. During this time he is living with the Servite monks in the same church.

**1501** Leonardo works on a small painting of the *Virgin and Child (Madonna of the Yarnwinder)* for Florimond Robertet, Secretary to the King of France.

**1502** Round about June Leonardo sets out on travels in Central and Upper Italy with the notorious mercenary leader Cesare Borgia as his architect and military engineer. He makes maps and other items for the latter's campaigns.

**1503** In early March Leonardo is in Florence again and, in response to a commission from Francesco del Giocondo, starts on a portrait of his wife Lisa del Giocondo (*The Mona Lisa*), which greatly impresses the young Raphael. In October Leonardo starts on the most monumental of all his commissions as a painter, the wall-painting of the Battle of Anghiari in the Grand Council Chamber of the Palazzo Vecchio in Florence.

**1504** In July Leonardo's father dies at the age of 79.

**1506** In May Leonardo is given permission by the Florentine civic authorities to leave the town for three months. At this he leaves the wall-painting of the Battle of Anghiari unfinished and returns to Milan. This new move is above all a result of the wish of the French governor in Milan, Charles d'Amboise, to secure Leonardo's services. Following the intervention of his French patron, Leonardo then stays for more than three months in Milan.

D. Gandini
*Ludovico il Moro and his Wife Visit Leonardo's Last Supper,* 1845
Engraving, 142 x 196 mm

**1507** On account of the still unfinished wall-painting in the Palazzo Vecchio, and also of inheritance squabbles with his siblings, Leonardo spends a short time in Florence, but following yet another intervention, by the King of France, is allowed to relinquish his commitment to finishing the *Battle of Anghiari* and to return soon to Milan, where he paints a new version of the *Virgin of the Rocks* for the Franciscan Confraternity of the Immaculate Conception.

**1508–1512** Apart from a few short visits to Florence in 1508 and 1511, Leonardo stays almost exclusively in Milan, working mainly for Charles d'Amboise, the French Governor of the town. By now renowned as an artist, in August 1508 Leonardo completes the second version of the *Virgin of the Rocks* (London, National Gallery), submits designs for the Trivulzio monument, pursues his anatomical studies and in all likelihood also paints a version of *Leda and the Swan*, which has since been lost.

**1513** After the death of Charles d'Amboise in 1511, and the expulsion of the French from Milan in 1512, Leonardo goes to Rome with his new patron Giuliano de' Medici, the brother of Pope Leo X. It seems that in Rome he also works for Baldassare Turini, the Papal Treasurer.

**1514–1515** In the papal court Leonardo embarks on a whole variety of scientific experiments. In response to a commission from Leo X, he plans – amongst other things – the reclamation of the Pontini marshes south of Rome.

**1516** With the death of Giuliano de' Medici in March 1516 Leonardo once again loses his patron. Thus in winter 1516/1517 he takes up an invitation from the French King Francis I and goes as his court painter to France. He lives in Cloux, not far from the royal Castle of Amboise, occupies himself with scientific experiments, architectural designs and irrigation projects.

**1517** In October Cardinal Luigi d'Aragona visits the rapidly ageing Leonardo in Cloux and later reports on several paintings that he saw in the latter's workshop.

**1519** On 23 April, Leonardo makes his last will and testament, on 2 May he dies in Cloux, as legend would have it, with the King of France at his deathbed. In accordance with his own wishes he was buried in the Church of St. Florentine in Amboise. His grave was destroyed during the Huguenot Wars. However, the entry in the Church Register has survived: "In the cloister of this church was buried M. Leonardo da Vinci, a nobleman from Milan, engineer and architect to the King, state master of mechanics and onetime Director of Painting to the Duke of Milan."

**1520–1530** Leonardo's friend and pupil Francesco Melzi puts in order the manuscripts he has inherited from his master, and from the most

Paul-Prosper Allais
**Raphael in Leonardo's Atelier during the Painting of the Mona Lisa,** 1845
Engraving, 960 x 780 mm

important of these, compiles the so-called *Treatise on Painting*, a collection of practical and theoretical instructions for painters. Another pupil, Giacomo Salai, inherits the bulk of the paintings. On the violent death of Salai in Milan in 1525, his estate is found to contain the *Virgin and Child with St. Anne, St. John the Baptist, Leda and the Swan*, the *Mona Lisa*, another portrait and a painting of St. Hieronymus. It was probably not until the early 1530s that the King of France acquired some of these paintings, which are still to be seen in the Louvre today.

Claude-Marie-François Dien/Jules Richomme
**Leonardo's Death in the Arms of Francis I,** c. 1850
Engraving, 590 x 520 mm

# Bibliography

## General references

Leonardo da Vinci, *Das Buch von der Malerei*, ed. by H. Ludwig, 3 vol., Vienna 1882.

L. Beltrami, *Documenti e memorie riguardanti la vita e opere di Leonardo da Vinci*, Milan 1919.

J. P. Richter, *The Literary Works of Leonardo da Vinci*, 2 vol., 3rd Edition, Oxford 1970 (first 1883).

W. v. Seidlitz, *Leonardo da Vinci. Der Wendepunkt der Renaissance*, 2 vol., Berlin 1909.

P. C. Marani, *Leonardo. Catalogo completo dei dipinti*, Florence 1989.

A. Chastel (ed.), *Leonardo da Vinci, Sämtliche Gemälde und die Schriften zur Malerei*, Munich 1990.

D. Arasse, *Léonard de Vinci*, Paris 1997.

C. Vecce, *Leonardo*, Rome 1998.

C. Bambach (ed.), *Leonardo da Vinci, Master Draughtsman*, New York 2003.

F. Viatte/V. Forcione (eds.), *Léonard de Vinci, Dessins et manuscrits*, Paris 2003.

M. Kemp, *Leonardo da Vinci. The Marvellous Works of Nature and Man*, Oxford 2006.

F. Zöllner, *Leonardo da Vinci. Sämtliche Gemälde und Zeichnungen*, Cologne 2007.

## 1. Apprenticeship and Youth in Florence

A. Chastel, *Le Madonne di Leonardo* (XVIII Lettura Vinciana), Florence 1979.

A. E. Popham, *The Drawings of Leonardo da Vinci*, London 1952.

P. Hills, "Leonardo and Flemish Painting", in: *The Burlington Magazine*, 132, 1980, pp. 609–615.

J. Fletcher, "Bernardo Bembo and Leonardo's Portrait of Ginevra Benci", in: *The Burlington Magazine,* 131, 1989, pp. 811–816.

F. Zöllner, "Karrieremuster: Das malerische Werk Leonardos im Kontext seiner Auftragsbedingungen", in: *Georges-Bloch-Jahrbuch*, 2, 1995, pp. 57–73.

D. A. Brown, *Leonardo da Vinci. Origins of a Genius*, New Haven/London 1998.

## 2. Beginnings without Ends

H. Ost, *Leonardo-Studien*, Berlin/New York 1975.

M. Lisner, "Leonardos Anbetung der Könige. Zum Sinngehalt und zur Komposition", in: *Zeitschrift für Kunstgeschichte*, 44, 1981, pp. 201–242.

A. Natali, "Re, cavalieri e barbari; le Adorazioni dei Magi di Leonardo e Fillipino Lippi", in: *Gli Uffizi, studi e ricerche*, 5, 1988, pp. 73–84.

F. Fehrenbach, *Licht und Wasser. Zur Dynamik naturphilosophischer Leitbilder im Werk Leonardo da Vincis*, Tübingen 1997, pp. 89–114.

M. Wiemers, *Bildform und Werkgenese. Studien zur Zeichnung in der italienischen Malerei zwischen 1450 und 1490*, Munich/Berlin 1996.

## 3. New Artistic Departures in Milan

J. Snow Smith, "Leonardo's Virgin of the Rocks (Musée du Louvre): A Franciscan Interpretation", in: *Studies in Iconography*, 11, 1987, pp. 35–94.

P. Venturoli, "L'ancona dell'immacolata concezione di San Francesco Grande a Milano", in: *Giovanni Antonio Amadeo*, ed. by J. Shell and L. Castelfranchi, Milan 1993, pp. 421–437.

C. Gould, "The Early History of Leonardo's Vierge aux Rochers", in: *Gazette des Beaux Arts*, 124, 1994, pp. 216–222.

*Leonardo da Vinci. Engineer and Architect*, cat. d'exposition, Montreal 1987.

R. Schofield, "Amadeo, Bramante and Leonardo and the 'tiburio' of Milan Cathedral", in: *Achademia Leonardi Vinci*, 2, 1989, pp. 68–100.

## 4. The Artist as Natural Scientist

F. M. Feldhaus, *Leonardo der Techniker und Erfinder*, Jena 1922.

C. D. O'Malley/J. B. de C. M. Sauders, *Leonardo da Vinci on the Human Body*, New York 1952.

M. Kemp, "Il concetto dell'anima in Leonardo's Early Skull Studies", in: *Journal of the Warburg and Courtauld Institutes*, 34, 1971, pp. 115–134.

F. Zöllner, *Vitruvs Proportionsfigur*, Worms 1987.

M. W. Kwakkelstein, *Leonardo da Vinci as a Physiognomist*, Leyden 1994.

## 5. Leonardo: Court Artist in Milan

F. Malaguzzi-Valeri, *La Corte di Ludovico il Moro*, 4 vol., Milan 1915–1923.

J. Shell/G. Sironi, Cecilia Galleriani, "Leonardo's Lady with an Ermine", in: *Artibus et Historiae*, 13, 1992, pp. 47–66.

*Leonardo da Vinci's Sforza Monument Horse. The Art and the Engineering*, ed. by Diane Cole Ahl, London 1995.

E. Möller, *Das Abendmahl des Leonardo da Vinci*, Baden-Baden 1952.

C. Gilbert, "Last Suppers and their Refectories", in: *The Pursuit of Holiness in Late Medieval and Renaissance Religion*, ed. by Charles Trinkaus and Heiko A. Obermann, Leyden 1974, pp. 371–407.

D. Rigaux, *A la table du Seigneur. L'Eucharistie chez les primitifs italiens (1250–1497)*, Paris 1989.

## 6. Restless Interlude

J. Wasserman, "The Datting and Patronage of Leonardo's Burlington House Cartoon", in: *Art Bulletin*, 53, 1971, pp. 312–325.

E. H. Gombrich, "Leonardo's Method of Working out Compositions" in: ibid., *Norm and Form*, Oxford 1966, pp. 58–63.

J. Nathan, "Some Drawing Practices of Leonardo da Vinci: New Light on the Saint Anne", in: *Mitteilungen des Kunsthistorischen Instituts in Florenz*, 36, 1992, pp. 85–102.

A. Perrig, "Leonardo: Die Anatomie der Erde", in: *Jahrbuch der Hamburger Kunstsammlungen*, 25, 1980, pp. 51–83.

E. Battisti, "Le origini religiose del paesaggio veneto", in: *Venezia Cinquecento*, 1, 1991, H. 2, pp. 9–25.

*Leonardo da Vinci. The Mystery of the "Madonna of the Yarnwinder"*, ed. by M. Kemp, Edinburgh 1992.

## 7. The Battle of the Giants: Leonardo and Michelangelo

J. Shell/G. Sironi, "Salai and Leonardo's Legacy", in: *The Burlington Magazine*, 133, 1991, pp. 95–108.

F. Zöllner, *Leonardo da Vinci. Mona Lisa. Das Porträt der Lisa del Giocondo*, Frankfurt 1994.

S. Kress, *Das autonome Porträt in Florenz*, Phil. Diss., Gießen 1995.

E. H. Gombrich, "Ideal and Type in Italian Renaissance Painting", in: ibid., *New Light on Old Masters*, Oxford 1986, pp. 89–124.

F. Zöllner, *La Battaglia di Anghiari di Leonardo da Vinci fra mitologia e politica* (XXXVII Lettura Vinciana) Florence 1998.

## 8. The Last Years

A. H. Allison, "Antique Sources of Leonardo's Leda", in: *Art Bulletin*, 56, 1974, pp. 375–384.

L. H. Heydenreich, "Bemerkungen zu den Entwürfen Leonardos für das Grabmal Gian Giacomo Trivulzios", in: *Leonardo-Studien*, ed. by G. Passavant, Munich 1988, pp. 123–134.

R. Fritz, "Zur Ikonographie von Leonardos Bacchus–Johannes", in: *Museion. Studien aus Kunst und Geschichte für Otto H. Förster*, Cologne 1960, pp. 98–101.

P. Barolsky, "The Mysterious Meaning of Leonardo's Saint John the Baptist", in: *Source*, 8, 1989, pp. 11–15.

C. Pedretti, *Leonardo da Vinci. The Royal Palace at Romorantin*, Cambridge (Mass.) 1982.

# Epilogue

Since the first edition of this book there have been two very significant discoveries with regard to the paintings of Leonardo da Vinci. On the one hand, the use of infrared reflectography has resulted in the detection of several underdrawings by Leonardo under the uppermost paint layer of the *Virgin of the Rocks* in London. The drawings are strikingly at variance with the composition of the finished painting (Luke Syson/ Rachel Billinge, *Leonardo da Vinci's Use of Underdrawing in the 'Virgin of the Rocks' in the National Gallery and 'St Jerome' in the Vatican*, in: Burlington Magazine, 147, 2005, pp. 450–463). On the other hand, the discovery of the so-called Cicero edition in the library of Heidelberg University confirms my view that the *Mona Lisa* was begun in 1503 and does in fact portray Lisa del Giocondo, the wife of the Florentine merchant Francesco del Giocondo (Veit Probst, *Zur Entstehungsgeschichte der Mona Lisa. Leonardo da Vinci trifft Niccolò Machiavelli und Agostino Vespucci*, Heidelberg 2008, http://archiv.ub. uni-heidelberg.de/artdok/volltexte/2008/410/).

This second discovery concerns a comment by the Florentine chancellery official Agostino Vespucci handwritten in the margin of an incunabulum of the letters of Cicero. A good friend of Leonardo's, Vespucci names *The Virgin and Child with St Anne* along with the *Mona Lisa* and *The Battle of Anghiari* for the Great Hall of the Florentine seat of government. His reference to the *Mona Lisa* is particularly significant because, until now, the occasionally contradictory notes concerning the portrait had dated from 1517 at the earliest. In his note, Vespucci comments on a remark of Cicero's concerning the ancient painter Apelles, who in a painting of Venus had executed the head and breast completely but left the remaining parts unfinished. Vespucci's comment runs as follows:

"Apelles pictor. Ita Leonardus Vincius facit in omnibus suis picturis, ut enim caput Lise del Giocondo et Anne matris virginis. Videbimus, quid faciet de aula magni consilii, de qua re convenit iam cum vexillifero. 1503 Octobris." (The painter Apelles. Leonardo da Vinci does it like this in all his pictures, such as for example the head of Lisa del Giocondo and that of Anna, the mother of the Virgin Mary. We will see what he will do with regard to the Great Hall, about which he has just reached agreement with the standard-bearer. October 1503).

# Photo credits

The publishers and the author would like to thank those museums, archivists, collectors and photographers who have supported them in producing this work. In addition to those persons and institutions cited in the legends to the pictures, the following should also be mentioned:

© Bayer & Mitko-ARTOTHEK: p. 6
© ARTOTHEK: p. 16
© Bildarchiv Preussischer Kulturbesitz: p. 7
© Czartoryski Foundation, Cracow, p. 44, Photo © SCALA
© Bridgeman Art Library, London: pp. 34, 80

© The British Museum: pp. 9, 17, 23, 61
© Elke Walford, Hamburg: p. 24
© Photo Bulloz: pp. 32, 33
© Photo Liverani: p. 72
© Photo Saporetti: p. 59
© Photo Böhm: pp. 36, 38, 74
© Photo INDEX/Pizzi: pp. 50–51
© Photo Vasari: p. 72
© Photo Veneranda Biblioteca Ambrosiana: p. 48
© SCALA: p. 22
© Photo Dénes Józsa: p. 70
© Photo Paolo Tosi: pp. 10–13, frontispiece, pp. 24, 25, 27

© Photo RMN – Michèle Bellot: pp. 26, 63, 65, 76
© Photo RMN – J. G. Berizzi: pp. 15, 35
© Photo RMN – R. G. Ojeda: pp. 8, 73
© Photo RMN – C. Jean: pp. 49, 64, 87
© Photo RMN – Gérard Blot/Jean Schormans: p. 28
© Photo Bob Grove: pp. 19, 20
The Royal Collection
© Her Majesty Queen Elizabeth II: pp. 14, 18, 39, 40, 41, 42, 43, 46, 50, 51, 56, 57, 67, 68, 75, 78, 79, 82, 83, 84, 86, 88, 89, 90, 91
© Leipzig, Institut für Kunstgeschichte: pp. 30, 37, 54, 55, 74, 76, 92, 93, 94

TASCHEN
est.1980

TASCHEN
est.1980

TASCHEN
est.1980

TASCHEN
est.1980

TASCHEN
est.1980

TASCHEN
est.1980

TASCHEN
est.1980

TASCHEN
est.1980

TASCHEN
est.1980

TASCHEN
est.1980

TASCHEN
est.1980

TASCHEN
est.1980

TASCHEN
est.1980

TASCHEN
est.1980

TASCHEN
est.1980

TASCHEN
est.1980

TASCHEN
est.1980

TASCHEN
est.1980

TASCHEN
est.1980

TASCHEN
est.1980

TASCHEN
est.1980

TASCHEN
est.1980

TASCHEN
est.1980

TASCHEN
est.1980

TASCHEN
est.1980

TASCHEN
est.1980

TASCHEN
est.1980

TASCHEN
est.1980

TASCHEN
est.1980

TASCHEN
est.1980

TASCHEN
est.1980

TASCHEN
est.1980

TASCHEN
est.1980

TASCHEN
est.1980

TASCHEN
est.1980

TASCHEN
est.1980

TASCHEN
est.1980

TASCHEN
est.1980

TASCHEN
est.1980

TASCHEN
est.1980

TASCHEN
est.1980

TASCHEN
est.1980

TASCHEN
est.1980

TASCHEN
est.1980